UP AGAINST THE WALL

Published and distributed by RotoVision SA

Route Suisse 9

CH-1295 Mies

Switzerland

Sales, Production & Editorial Office

Sheridan House

112–116A Western Road

Hove, East Sussex

BN3 1DD, UK

Tel: +44 (0)1273 72 72 68

Fax: +44 (0)1273 72 72 69

Email: sales@rotovision.com

Website: www.rotovision.com

Copyright © RotoVision SA 2002

Written and Designed by Visual Research

Russell Bestley and Ian Noble

Commissioning Editor Kate Noël-Paton

Cover and Location Photography by Sarah Dryden

Studio Photography by Xavier Young

Practicalities by Tony Pritchard

Production and separations by ProVision

Pte. Ltd., Singapore

Tel: +656 334 7720

Fax: +656 334 7721

ISBN 2-88046-561-3

10 9 8 7 6 5 4 3 2 1

UP AGAINST THE WALL

RUSSELL BESTLEY AND IAN NOBLE

RotoVision

CONTENTS

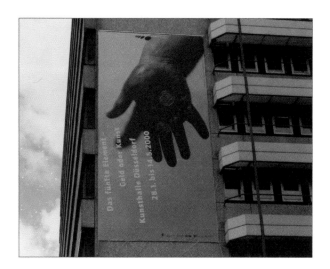

Public Spaces

> The ironic overtones of this book's title, Up Against the Wall, allude to the fact that the poster has received less attention than other forms from those interested in graphic design as a discipline. This may be due to its timeless quality, as it remains relatively unaffected by the many changes within the profession and the wider culture it serves. Yet this unique medium holds a particular attraction for the designer, and, despite the many claims of various new media as being the dominant forces in contemporary communication, the poster continues to thrive and prosper. Indeed, as German designer Sandy K. states (p153), "to be in a position to design posters is a great gift. I don't know any graphic designers who would say no to designing a poster."

> The title also reflects the location or site of the poster; because it is a graphic medium existing in a public space, its form demands a particular relationship with the viewer. As a blunt instrument of communication, the poster grabs attention by speaking with a loud voice. The strategies employed by designers working with this medium are very different from that of the book designer, for instance, who is able to build upon the tactile, intimate relationship between the reader and their hand-held object. This is not to suggest that the approaches to poster design documented here do not employ subtlety or an engagement with their audience; just that they operate in a different manner directly related to the scale of the object and the influence of its public location.

> The factors of scale and location present the poster designer with a range of opportunities not offered by graphic design projects of a smaller scale. Although many of the fundamental concerns of the graphic designer are relevant to this arena of work – the relationship between type and image or the use of colour and mechanical reproduction, for instance – the manner in which they are explored and utilised differs greatly.

> The dynamics of this form of communication – operating both at a distance, from across a street or room, and in close proximity – require the poster designer to construct a visual conversation with the viewer that is both instantly arresting or enticing while at the same time delivering a range of often complex information on a number of levels.

Cultural Agendas

> Poster design occupies a unique position. Although sometimes used as a commercial device, its content is more often related to a social or cultural concern or is connected to a significant event. As Polish poster designer Roman Cieslewicz has said, "posters need powerful occasions and significant subjects."

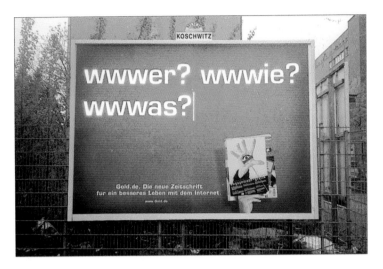

1 2 3 4

Posters in public locations
(1) Uwe Loesch, (2) Alain le Quernec,
(3) Sandy K., (4) Alain le Quernec.

> In many cases the scale of the poster and its relationship to an artistic event have allowed the poster to avoid the unnoticed and ephemeral existence of most graphic design visible in the street. It has become a familiar item in the home of the concert goer or exhibition visitor as a significant or meaningful reminder; encapsulating the spirit or attitude of a performance or experience of an event.

> The poster has begun to be seen as valuable and collectable; it has appeared in museums and galleries as an artefact in its own right, or as a visual complement to a historic event – in the process achieving a level of respectability not afforded to most graphic output. Yet at the same time it remains resolutely of the street – a device employed to communicate an idea or opinion that could only have been designed with a very public location in mind. So what is it about this form of graphic production that has persisted as an effective medium for so long? And why is the poster still employed by designers on a regular basis as a solution to the communication of an idea or message?

> The poster's multiple existence as a tentacle of commerce, as a visual messenger of culture and as a vehicle for alternative or subcultural views may point to its enduring nature. Hopefully, over the course of this book a range of answers may appear.

> This book isn't intended to provide a history of poster design – there are already a wide range of publications on the subject – but to offer a very international collection of recent work from across the broad spectrum of approaches to poster design. In addition, insights are offered into the intention and working processes employed by individual designers.

> The book has been designed and structured to provide access not only to finished projects but also the stages involved in the creation of a poster. In many cases individual posters are supported by developmental work as well as by detailed captions and information. Interviews with featured designers such as David Tartakover and Stefan Sagmeister uncover the background surrounding a particular poster or provide a rationale for working methods in general.

> The thematic chapters explore the format of the poster; its size and scale employed to different effect; the use of posters in series to communicate a message over a period of time or to unite an identity for a gallery, museum or organisation; the various employment of the single image as a central device; the concentration on typographic form and visual word play; and the combination or relationship between word and image to create meaning.

The King of the Street

> The poster remains perhaps the most resonant, intrinsic and enduring item in the repertoire or arsenal of the graphic designer. From the agitational and political to the promotional, persuasive and informational, the poster in all its forms has persisted as a vehicle for the very public dissemination of ideas, information and opinion.

Reflecting Culture

> This unique form of communication, tracing the history and development of graphic design, acts as a form of commentary on the wider culture it is drawn from. Often reflecting the interests, needs and opinions of this same audience, it could be argued that in many cases the poster can be seen as a cultural icon capturing the spirit or zeitgeist of a particular moment or time. The Israeli designer David Tartakover (pp94–97) has described his work as a "seismograph". This could be seen as part of a larger reflexive tradition within graphic design and, in his words, "a way of reacting to events... to alter opinion and attitudes." At times this may mean working on a rapid schedule of production to make a poster that is on the streets within days or hours of an event.

> The nature of graphic design activity continues to change and accommodate new and more sophisticated approaches, in particular reacting to the influence of new technologies and the growing impact of multi-media. Within this environment of change and reappraisal the poster – which is the most traditional of forms within graphic design, produced with ink and paper and often originated and constructed by hand using defiantly low technologies such as scissors and pencil – continues to hold a peculiar attraction for graphic designers.

New and Old Media Influences

> Our daily life and culture has become predominantly moving-image based, in large part due to the impact and influence of television and the internet. The ability of these 'new media' to deliver images as they happen around the globe to our front room and workplace presents a challenge to the more traditional and familiar forms of media with which the poster shares its history. Perhaps the transient and intangible nature of, for instance, the internet has encouraged an examination of our relationship to more historic and established forms of communication and their value or function in the future. The poster, similar to the book in that it is print-based and linear in form, has undergone a renaissance both in status and in interest in general.

> This has offered the opportunity to reappraise the graphic output of poster designers from our recent past such as

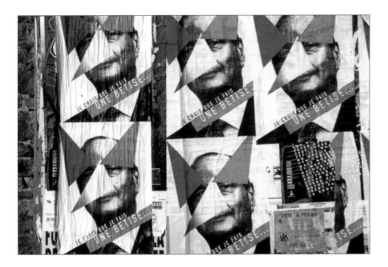

1 2 3 4

Posters in public locations
(1) Sandy K., (2) 8vo,
(3) Alain le Quernec, (4) Pascal Colrat.

Cieslewicz, Tomaszewski, Müller-Brockmann and the collective Grapus, and to consider their influence on those working today within the field of poster design. It is certainly possible to trace a connection from the Polish poster designer Tomaszewski – who as a tutor became a strong influence on designers such as Pierre Bernard and Gérard Paris-Clavel of Grapus – and in turn to younger designers such as Pascal Colrat and Sandy K., whose work is collected in this book.

In the Beginning was the Word (and Image)

> As Richard Hollis describes in the introduction to Graphic Design – A Concise History, "It begins with the poster. As a single sheet, unfolded and printed only on one side, it is the simplest medium for graphic design. It exemplifies its essential elements – alphabet and image – and its means of reproduction."

> Not much has changed during the last 100 years in how a poster functions or how an audience may react or respond to it. The directness – central to the success of a poster – its scale, and its public, rather than intimate, relationship with a viewer, does not negate subtlety, intelligence or wit in the process of communication. The (poster) designer's tools, the elements Hollis refers to as alphabet (type) and image, remain as significant now as in the past. The poster is perhaps one of the few remaining sites for the graphic designer where the very essence of simplicity and functionality – the reduction of form or the use of visual metaphor – give rise to the purest form of visual communication.

Site Specific

> It is significant that many of the sites or locations for the poster have either changed or disappeared, though the means of production of those remaining may have become more sophisticated. We have become more used to the billboard – the bastard offspring of the King of the Street – as a blunt instrument for the selling of anodyne products. The poster shares some characteristics with the billboard, but also has a wider range of functions which go beyond that of commercial persuasion. It is equally possible to trace a more substantial history of the poster as a non-commercial vehicle more connected to the communication of messages and information that challenge authority and the dominant ideology.

> The poster has a variety of applications, and is often employed in the service of the culture industries to promote an event or to publicise a meeting or performance. Equally the poster provides an economically viable voice of dissent or alternative opinion, in many cases for those who would have no other means of promoting their cause.

Inherited Traditions

> The work featured in this book from designers around the world such as Stefan Sagmeister in the US, Alain le Quernec and Association Commune in France, David Crow in England, Ralph Schraivogel in Switzerland, Koji Mizutani in Japan and Leonardo Sonnoli in Italy is united in its concern to develop and advance the traditions these designers have inherited.

> The poster allows the designer a larger frame within which to work and play than most graphic design projects. Some of those featured in this publication are poster designers by occupation or calling; others continue to work in other aspects of the profession in tandem with their poster work.

> This book does not place a distinction or hierarchy on the various functions of the poster. The reader will find posters that celebrate the economic, the cultural and the social and political. Often the work displayed is commissioned, but in other cases the designer has acted as both client and author, producing the work for its own ends and because the need to make a comment or statement on a particular situation or event has dictated it.

> This self-authored approach to the communication of public messages reflects the history of the poster as a medium used to engage, inform or provoke. By harking back to a long-standing tradition in the production of posters, and to a lineage of designers for whom ideological concerns were as important as formal considerations, this builds on a rich visual heritage.

> The poster, as a form that delivers messages to a wide audience in a very direct fashion, and that can be produced on even the most limited of budgets, continues to be the most appropriate medium for this intersection between personal agency and public expression.

Behind the Wall

> We are indebted to the many designers from around the world who have allowed us access to their work and who have given so freely of their time, elaborating on their working methods to provide a background and context for individual projects. Without this collaboration we would have been unable to offer the level of detail and insight we hope is available here.

> Many of the designers featured in this publication have employed their abilities as visual communicators and poster designers to give a voice to the disenfranchised or those in need of support, or to offer alternative or dissenting opinions. Others have extended the discussion of what a poster is with new and

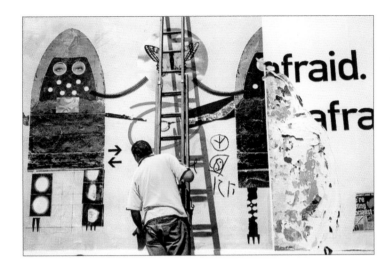

1 2 3 4

Posters in public locations
(1) Uwe Loesch, (2) Studio Dumbar
(photography by Peter Leurink),
(3) David Crow, (4) Uwe Loesch.

informative approaches based on a personal exploration or
advances in technologies. Many have found space within a
commercial brief to extend the objectives of a client; to transcend
the selling of an idea or product and to create a message that has
an enduring truth or connection to its intended audience.

> What unites the work here is the effective communication of
an idea or message. The Polish poster designer Roman Cieslewicz
said that as designers we have a responsibility to find images that
clean the eye – a sentiment we hope is extended within
the pages of this book.

Ian Noble and Russell Bestley

MEASURED APPROACHES

> One of the central fascinations of the poster for the designer is the opportunity presented by its scale and format – unique among other forms of graphic production. Other print work in the graphic designer's repertoire may be more tactile, more intricate or more complex, but few afford the opportunity to work on such a big scale and format.

Large Scale Formats

> Often initial decisions concerning the scale or shape of a poster can be driven by budgetary concerns, requiring the poster designer to work within the standard paper sizes such as the Imperial or DIN system (see pp156–157). At other times the format of a poster can be influenced by its location – individual commissions presenting the opportunity to produce work on a large scale or in an unusual shape. The resulting form that a poster may take can also be driven by its content or message – the designer exploring the most appropriate manner in which to communicate to their intended audience sometimes arriving at unlikely or unexpected outcomes.

> These factors of size, format and presentation require the poster designer to engage with a range of challenges different from those presented by many other forms of graphic design. The manner of communication changes dramatically as the scale of the medium is increased. The fact that this mode of communication will be viewed from both a distance and at close quarters, and that the public space in which the poster exists is influenced by the environment surrounding it, are key considerations beyond that of the content and message. As German designer Sandy K. observes when discussing his own work (pp150–153), "... if you design for the street the design process does not end at the edge of the poster."

> The requirement to think beyond the page is influential in the poster designer's operation. While the scale may deny a more intimate or tactile relationship with an audience, such as that provided by the format of a book intended to be held in the hand, it can still produce sophisticated solutions. British designer Hamish Muir (pp60–63) suggests that these might be seen as "...communicating on a level that transcends the information it's communicating."

> The 'public space' in which a poster exists gives the designer the opportunity to create grand gestures that can dominate the immediate surroundings and arrest the passer-by – drawing them in and inviting reflection. This can be seen in the large scale work produced by Uwe Loesch for the Museum für Kunsthandwerk Frankfurt am Main, Germany (pp22–23), which occupies the entire side of a building. Other designers may use the opportunities presented by the large single sheet to explore alternative poster formats, in the process confounding their audiences' expectations and familiarity with what a poster might be. These experimental approaches to form and scale can involve the designer crossing boundaries into three-dimensional space, architecture and the 'private space' of the advertising hoarding.

Strategies of Engagement

> Scale is not the only factor that a designer might choose to effect in their work. Both Uwe Loesch and Daniel Eatock, for instance, explore strategies in which their audience might engage with the form of their posters. In the poster designed for a cultural festival in the city of Duisburg in Germany (pp16–17) German designer Loesch created a poster that has also become a piece of theatre or performance. A huge three-dimensional globe created from maps of the city was also used as part of the festival celebrations itself – participants rolling the ball around the streets as a performance and extending the poster's idea of the relationship between the map – a flat representation of a place – and the actual physical space.

Automatic Transmission

> British designer Daniel Eatock approaches the notion of a physical relationship with a printed poster in a different manner in the self-authored work produced while a student at the Royal College of Art in the UK (pp18–19). Eatock's Utilitarian poster is an attempt to create an automatic poster – a 'blank form' that is only complete when the viewer contributes to the work by the addition of their own comments, views or observations. The poster is printed in one colour onto cheap newsprint paper with headed sections that are left blank for later additions. Each section is titled to give the participant direction with headings such as 'Description of event/happening', 'Title' and even the provision of a space where they are invited to add an illustration, doodle or image. This work, captioned by Eatock with the statement "say yes to fun and function and no to seductive imagery and colour", finds a visual form for the discussion of the relationship between the designer's work and their audience. It uses the notion of a dialogue between designer and audience to

acknowledge the shared responsibility for the construction of each individual poster's content and meaning.

> The physical nature of the poster is further developed by Uwe Loesch in the work produced for the Ludwig-Maximillans University entitled History as an Argument. In the poster, Loesch employs a visual metaphor for government censorship by the destruction of sensitive or potentially damaging documents. Loesch first designed a typographic poster containing the information about the event. This was almost destroyed by being partially fed through a shredding machine and was subsequently photographed for the final poster. The striking image created asks the viewer not only to consider its content and message but questions the reality of the surface they are looking at.

Collective Understandings

> In the work of two collectives, the Carrion Culture group (pp24–25) and Association Commune (pp26–27), very different approaches are adopted to the design of a poster. Working collaboratively to a common size and an unusual format of half Ao landscape and using only two colours each, the members of the Carrion Culture group explore ideas surrounding 'local and global environments'. The seven members of the group were geographically remote; they worked individually and the work was only collected together at the final stage for exhibition – the first time the work was able to be viewed together as a set.

> Association Commune worked collectively, in this case to produce work on a common theme of immigration and the plight of asylum seekers in Europe. The 19 members of the collective worked independently to a common brief – each member photographing detention centres and their surrounding locations. The final outcome was a large, non-standard-sized, single poster produced in two sections and printed in black and white. Designed to be read as a map of each location, the work was subsequently displayed in cities around France to raise awareness of the refugees currently in detention centres spread throughout Europe.

Extremities of Scale

> In the work of the British based Designers Republic (pp28–29) and David Crow (pp30–33) it is possible to see the extremes of scale employed to different effect. The self-authored work produced by Designers Republic to promote exhibitions of its work around the world employs an A3 format (see pp156–157) to interesting effect. The group, celebrated for the use of digital technology in their work, manage to create complex layered images with elements from diverse cultural origins to communicate their claim that "wherever we are based in the world, we are all suburbs of the global village."

> David Crow makes an unusual foray at the opposite end of the scale, producing a large scale poster (pp32–33) that utilises a large hoarding usually used as an advertising space in the UK city of Liverpool. The poster exploits the scale to present his observations of British political life and its relationship to the media. The phrase "it's hard to breathe when the air is so full of (spin) lies" is illustrated by Crow's own collage constructed of found material and media images of politicians – the central figures wearing masks with hoses struggling for air in the pollution surrounding them. The ironic use of a space more often associated with advertising and the selling of consumer products for a public art project also points to the difference in intention between the poster designer and the advertiser.

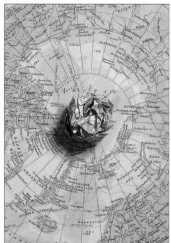

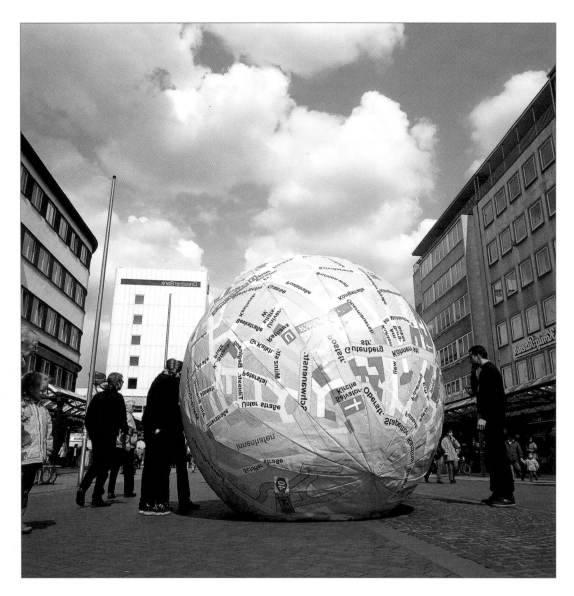

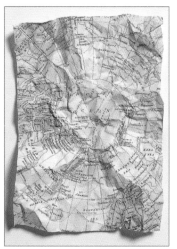

1 2 4
 3

UWE LOESCH:
The New City
841 x 1189mm Germany 1999

This poster was designed to promote the Cultural Festival of the State of North Rhine-Westphalia, an event commissioned by the city of Duisburg, Germany.

In his developmental work (2, 3), Loesch played with notions of maps and spheres (the relationship between the globe and the flat, plan view of the city street map), crumpling maps into balls and photographing the resulting irregular folds and perspectives. Some

of these ideas were then developed in a more refined form to create the final poster (4), which utilises overlaid digital outline type and perspective photography.

The idea of the poster was transformed into a large object – a 'globe' – printed with the map of the city of Duisburg. This was then rolled along the streets of the city during the festival's opening ceremony (1).

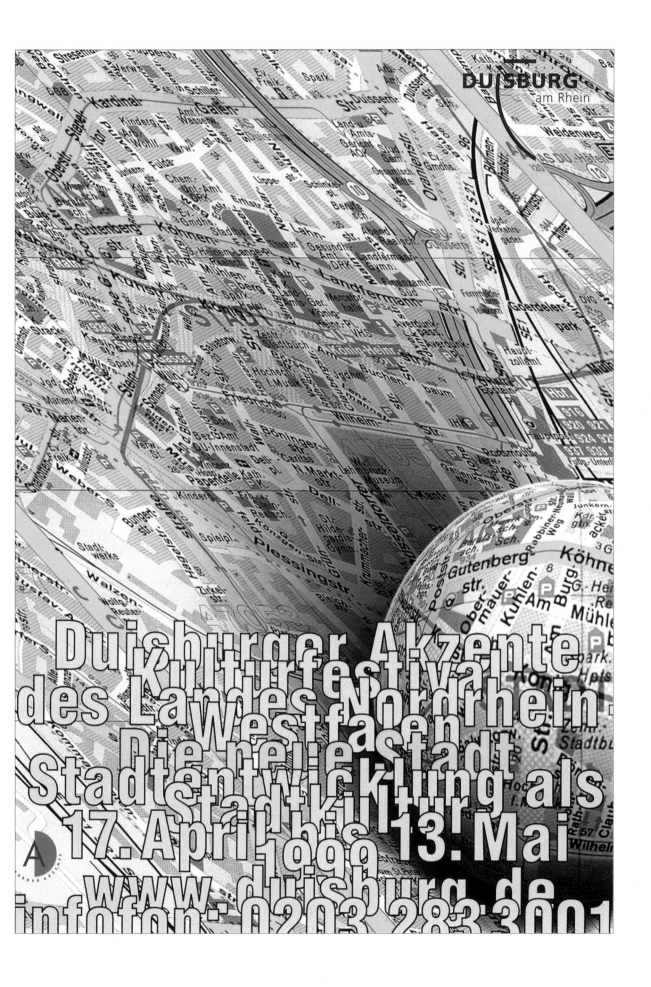

UTILITARIAN (DELETE AS NECESSARY) ADVERTISEMENT/ANN

THIS POSTER PROVIDES A FRAME & STRUCTURE FOR THE INFORMATION & DETAILS
COMPLETE THE EIGHT SECTIONS BELOW USING ANY METHOD OR MEDIUM
CONCEPT & DESIGN COPYRIGHT DANIEL EATOCK 1998 SAY YES TO FUN & FUNCTION

TITLE

DESCRIPTION OF EVENT/HAPPENING

DIAGRAM/DOODLE/DRAWING/IMAGE/PAINTING/PHOTOGRAPH/SCRIBBLE/ETCETERA

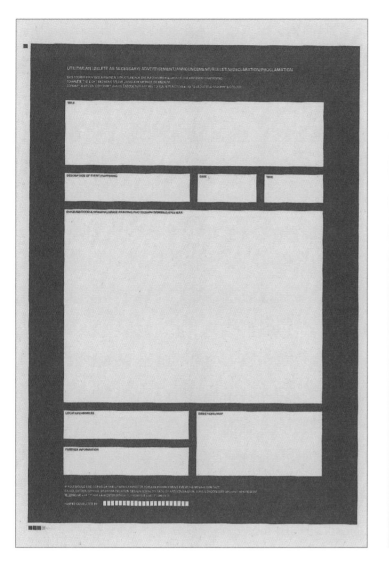

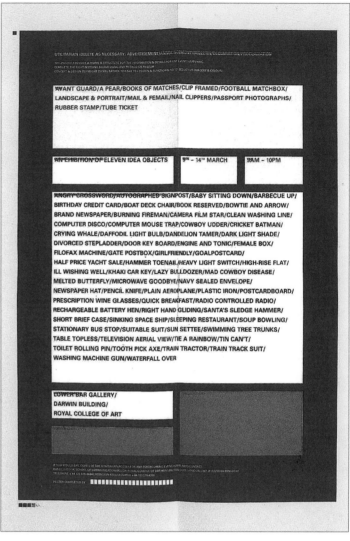

1 2 3

DANIEL EATOCK:
Utilitarian poster
594 x 841mm UK 1998

Eatock designed this poster to be used as a template (2), guiding the user through a series of steps in order to create their own advertisement. An example of the completed poster is shown in (3).

Silkscreen printed in one colour onto newsprint – low quality recycled paper used for the production of newspapers (also a material often used for test prints and for cleaning or drying screens) – the poster is divided into a number of hierarchical sections. These spaces relate to the range of essential details that might be necessary to publicise an event, and include a series of instructions for the potential user of the poster.

The user is asked to insert relevant information into the blank spaces (detail 1), such as the title of the event, venue, images, contact details etc, and to delete where appropriate the printed text heading each section. The work was produced for the Royal College of Art in London, UK, and includes Eatock's wry motto describing the rationale behind the poster; "say yes to fun and function and no to seductive imagery and colour."

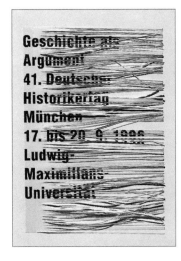 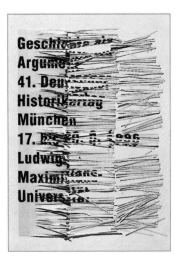 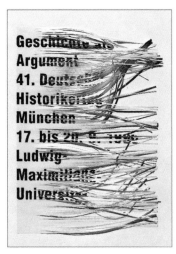 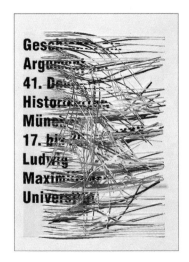

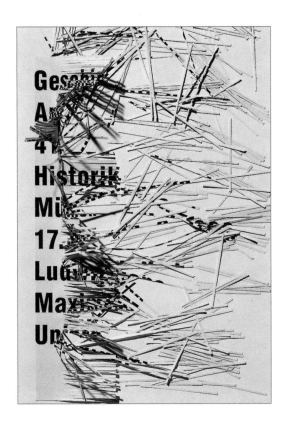 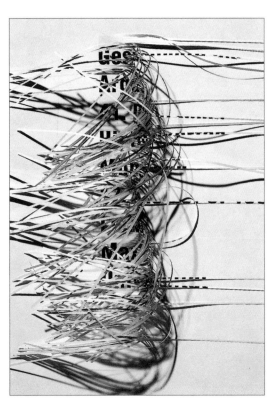

1 2 3 4 7
5 6

UWE LOESCH:
History as an argument
841 x 1189mm Germany 1996
This poster was created by the
designer with the use of a shredding
machine. Loesch aimed to visualise
the concept of a bureaucracy hiding
its past. As Loesch states, "the great
dictatorships of the 20th century left
millions of papers (a bureaucracy of
death). The Communists in the former
GDR destroyed most of the papers in
the last minute."

Loesch photographed a preset text
at various stages of the shredding
process (1–6), allowing himself to build
up a visual library of images to choose
from for production of the final poster
(7). Finally, the chosen image was
reproduced as a full size poster, with
a second text overlaid in red.

This presents something of a puzzle to
the viewer – a shredded poster within
a poster. From a distance, it can appear
that the poster itself has been cut in
this way, but upon closer inspection the
detail is revealed within the smaller
texts laid onto the image.

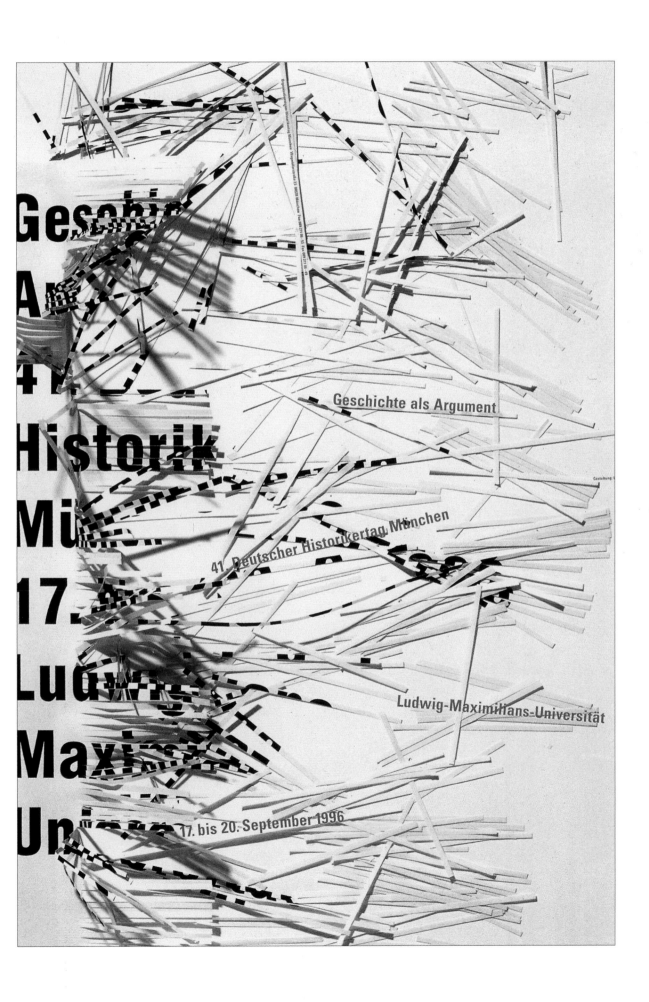

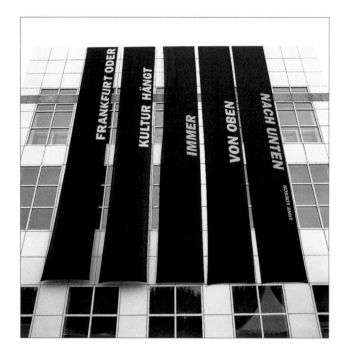

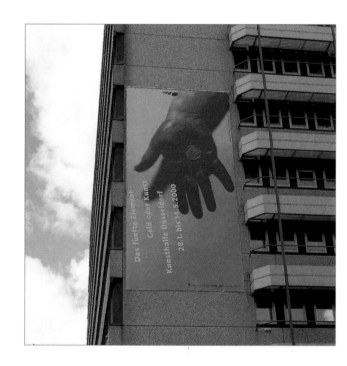

1 2 3
4

UWE LOESCH:

Large scale posters

Germany

Loesch designed a number of posters that were then reworked as large scale banners and 'megaposters'.

The poster designed for the Museum für Kunsthandwerk Frankfurt am Main, Germany in 1993, entitled **Culture always hangs from the top to the bottom** (1) was designed by Loesch as a small scale rough (2) and then reproduced as hanging banners across the front entrance to the museum.

By contrast to this work, Loesch has also designed posters that function both as standard-size posters and are then reprinted as what the designer terms 'megaposters' for large scale street displays. **The Fifth Element – Money or Art** (3), produced in 2000 for the Kunsthalle Düsseldorf, Germany, was originally offset litho-printed in full colour at a size of 841 x 1189mm, in order to be used at standard poster sites, but was also reproduced as a

very large banner to be displayed on the front of the museum and at street locations nearby (4).

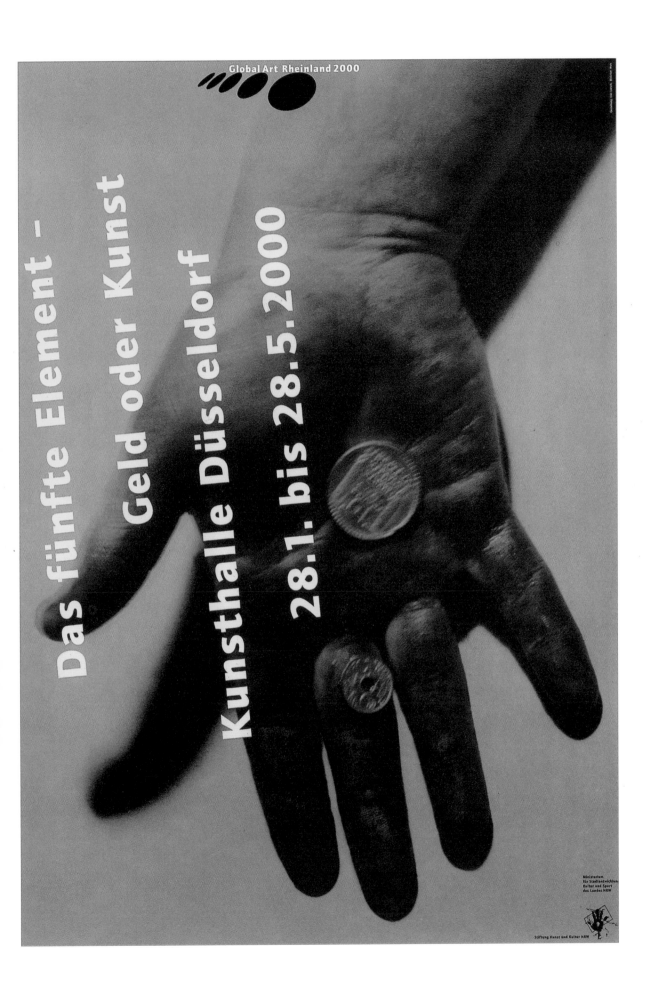

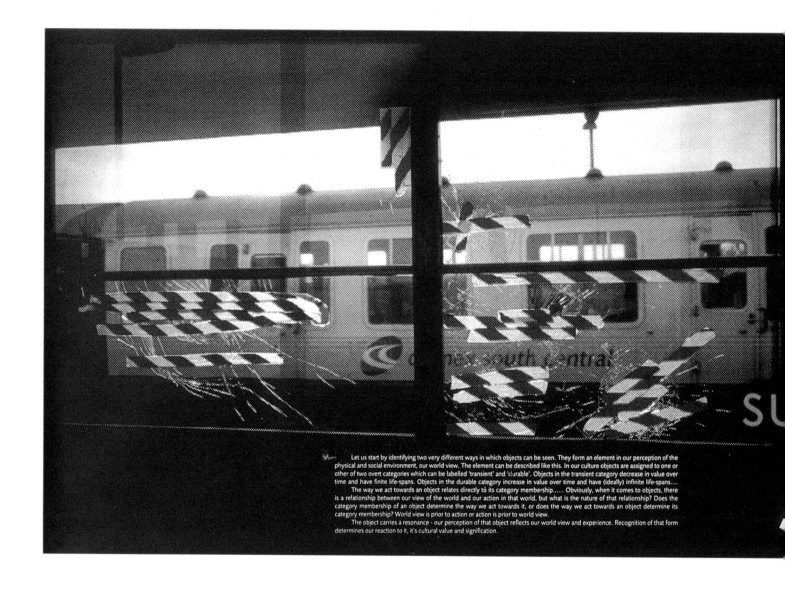

Let us start by identifying two very different ways in which objects can be seen. They form an element in our perception of the physical and social environment, our world view. The element can be described like this. In our culture objects are assigned to one or other of two overt categories which can be labelled 'transient' and 'durable'. Objects in the transient category decrease in value over time and have finite life-spans. Objects in the durable category increase in value over time and have (ideally) infinite life-spans....

The way we act towards an object relates directly to its category membership...... Obviously, when it comes to objects, there is a relationship between our view of the world and our action in that world, but what is the nature of that relationship? Does the category membership of an object determine the way we act towards it, or does the way we act towards an object determine its category membership? World view is prior to action or action is prior to world view.

The object carries a resonance - our perception of that object reflects our world view and experience. Recognition of that form determines our reaction to it, it's cultural value and signification.

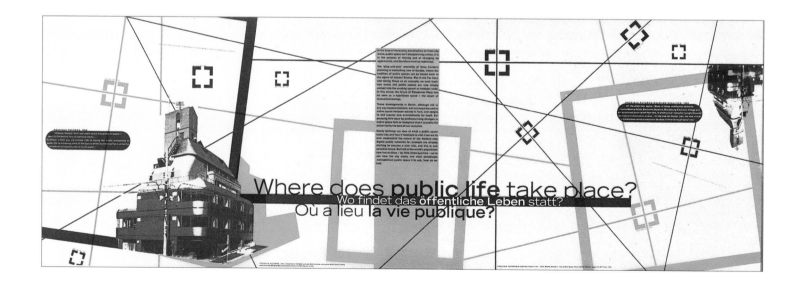

Where does public life take place?
Wo findet das öffentliche Leben statt?
Où a lieu la vie publique?

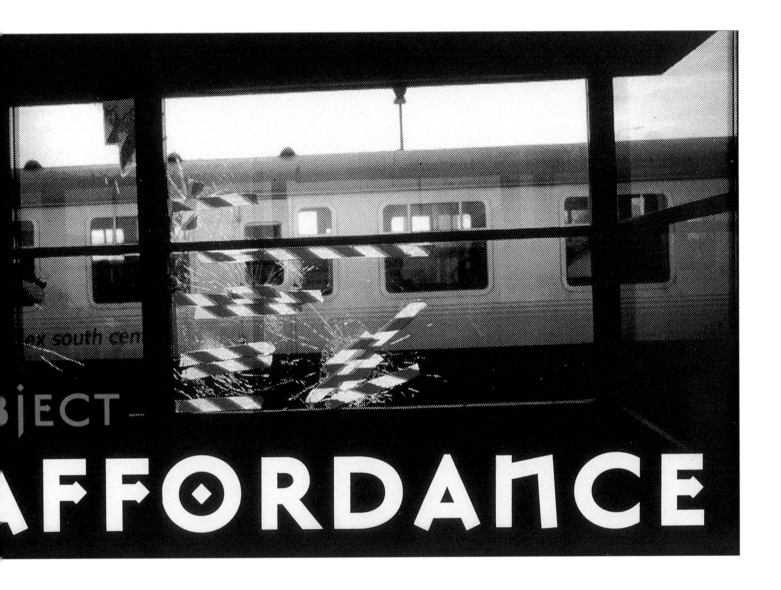

1
2

CARRION CULTURE:
Rat up a Drainpipe Edition
All 1200 x 420mm UK 1999

Two posters taken from a set of 14, designed and self-published by the Carrion Culture collective, a group of activists and designers from London and Portsmouth, UK, and Berlin, Germany. The group produced work each year for display at fringe events relating to the Chaumont Poster Festival, France, between 1996 and 2000. The theme for the posters in this collection was 'global and local environments', and each member of the collective designed two posters based on their personal interpretation of the brief. The title of the set, Rat up a Drainpipe, was a humorous reference to the discovery of a rat in the print room while the group were working on the posters.

Subject/Affordance (1) by Russell Bestley focuses on human responses to materials, in particular the notion of 'affordance' – the ways in which specific surfaces (for instance wood or glass) can provoke certain responses.

Where does public life take place? (2), by Ian Warner of design group grappa blotto, is a reflection on new developments around Potsdammerplatz in the centre of Berlin, and the increasing corporate commercialisation of the surrounding area.

All posters in the set were screenprinted in two colours, onto a translucent film as a base material. Designed to be site specific, the work was intended to be displayed at Chaumont across a large glass shop front, with texts on the central theme projected from behind, showing through the posters to form a linking visual narrative.

... maîtres-chiens de la brigade canine policière; enfouie dans une zone industrielle de

22 - Bobigny, 28 places. Photo Zinab Ledgham

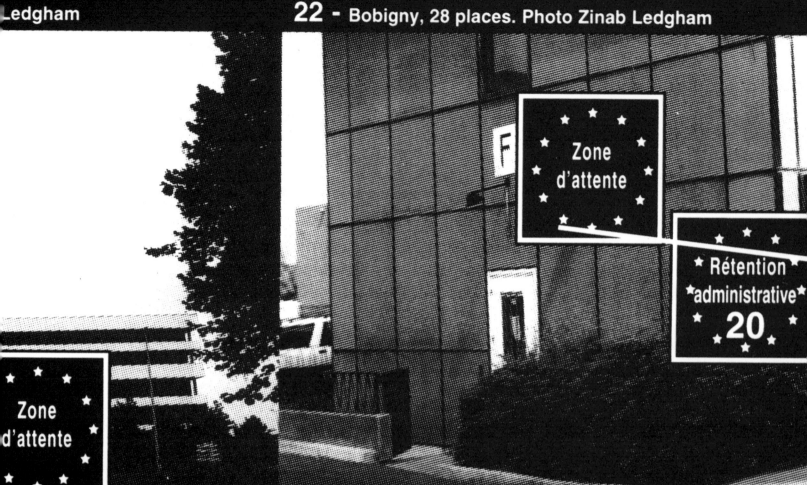

... l'Europe-forteresse. Certains demandeurs d'asile fuient peut-être la misère et non ...
...'Europe, on réagit tout autrement. Aux hommes, aux femmes et enfants qui essaien...

tos Dalila Mahdjoub

28 b

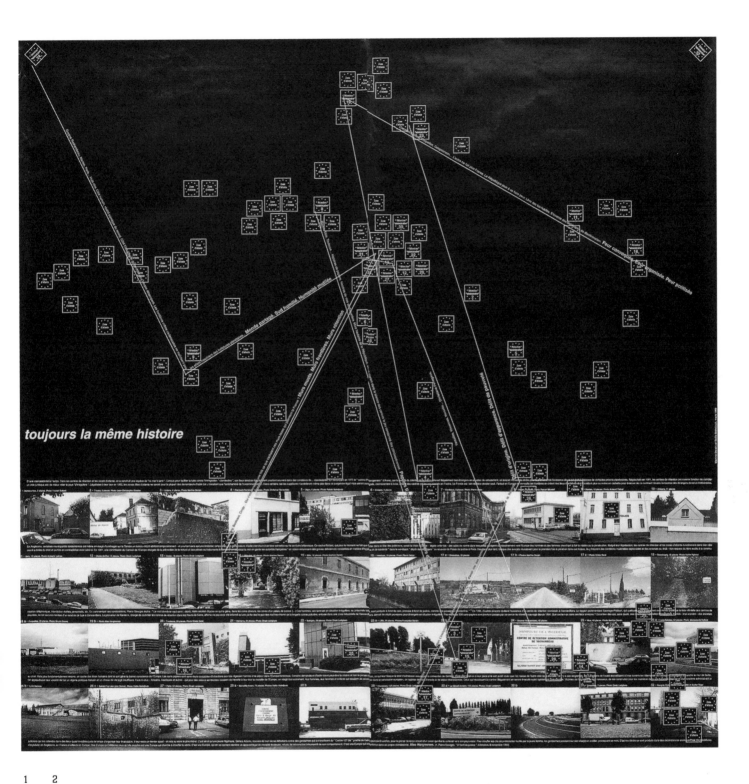

1 2

ASSOCIATION COMMUNE:
Toujours la Même Histoire
1760 x 1750mm France 1999

Designed by the Association Commune collective, this large format poster is silkscreen printed in two sections. The creation of the poster involved a collaboration between 19 designers and photographers, and documents locations around the 'centres de retention' in Europe, where immigrants are held awaiting deportation. The photographers were asked to avoid making a dramatic image, but instead to simply document the location around the centre (detail 1). The resulting two-section poster was displayed on walls in public locations in Marseilles and other French cities (2).

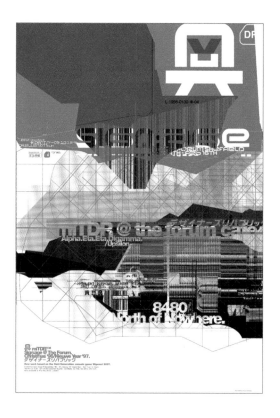

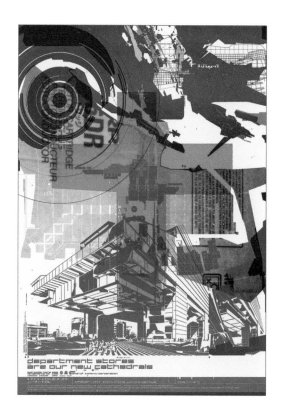

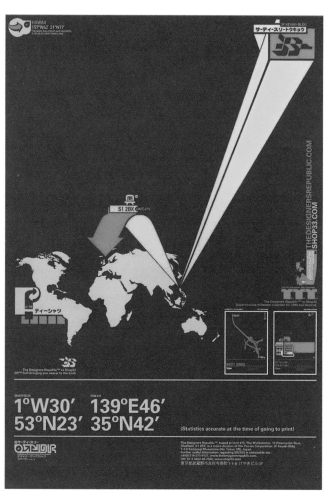

1 2 4
3

DESIGNERS REPUBLIC:
Promotion posters
All 297 x 420mm UK

Signage (1) was produced for the Designers Republic Signage Exhibition, at The Forum in Sheffield, UK, in December 1997. Featuring a densely layered collage of diagrams, Japanese and English text and digital marks, the poster was litho-printed in two colours, Pantone 186 and 8480 metallic.

Department Stores are our New Cathedrals (2) was created in October 1997 as Designers Republic 'New Year propaganda', and as promotion for the DR M-Art* Tour. The poster features an architect's drawing of a building together with a series of complex overlaid grids and diagrams. This collage of images is overprinted with a large, central, red cross (detail 4), symbolising religion. The Japanese store depicted is located at 1-4-1 Yokoami, Sumida-ku, East Central Tokyo. The poster is offset litho-printed in four Pantone colours: 804, 8282, 8621 and 8621.

DR vs Shop 33 (3) features a poster design that has been adapted from an original DR t-shirt from a series created for Shop 33, Tokyo, Japan. The designers wanted to make a geographic link between their home town of Sheffield, and the shop location in Tokyo.

The poster features a world map, with directional arrows linking the sites, together with longitude and latitude bearings for each city. The designers wanted to make a simple visual statement: "Where is Sheffield vs where is Tokyo? We're all suburbs of the global village." Created in June 1998, the poster was litho-printed as four colour process plus Pantone 8401.

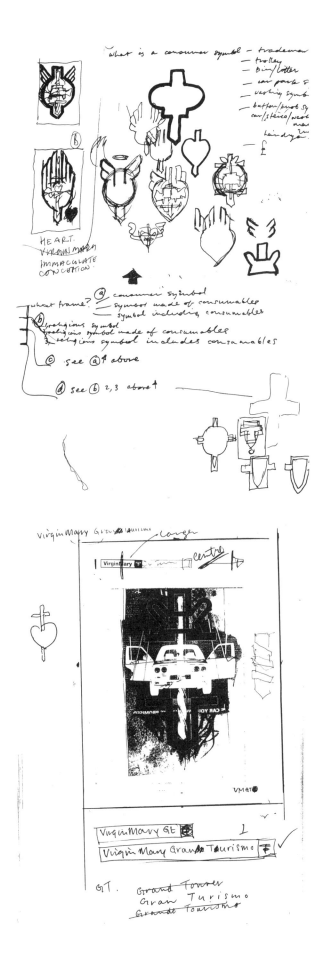

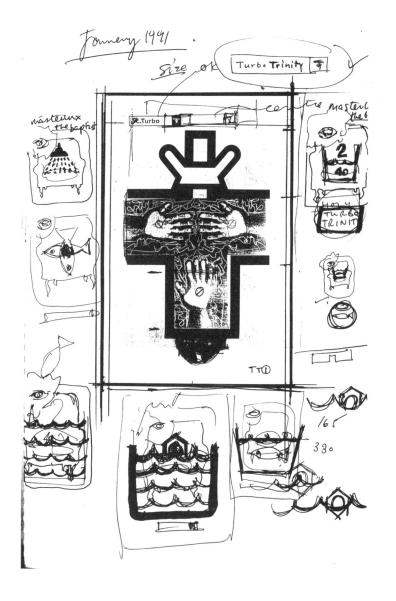

1 2

DAVID CROW:

Virgin Mary Gran Turismo

762 x 1016mm UK 1991

This poster was designed by Crow as a self-initiated work reflecting the designer's interest in the relationship between consumerism and religion. Initial notes and sketches (1) show Crow working through a range of ideas that link the theme of the cross with symbolism drawn from computer games, such as the Sony Playstation car racing game Gran Turismo.

Other elements developed from rough sketches to simple diagrammatic icons include armchairs, images representing consumerism (a supermarket trolley, litter bins) and religious iconography (including angels' wings, fish, and three hands representing the holy trinity). The final poster (2) was silkscreen printed in four colours.

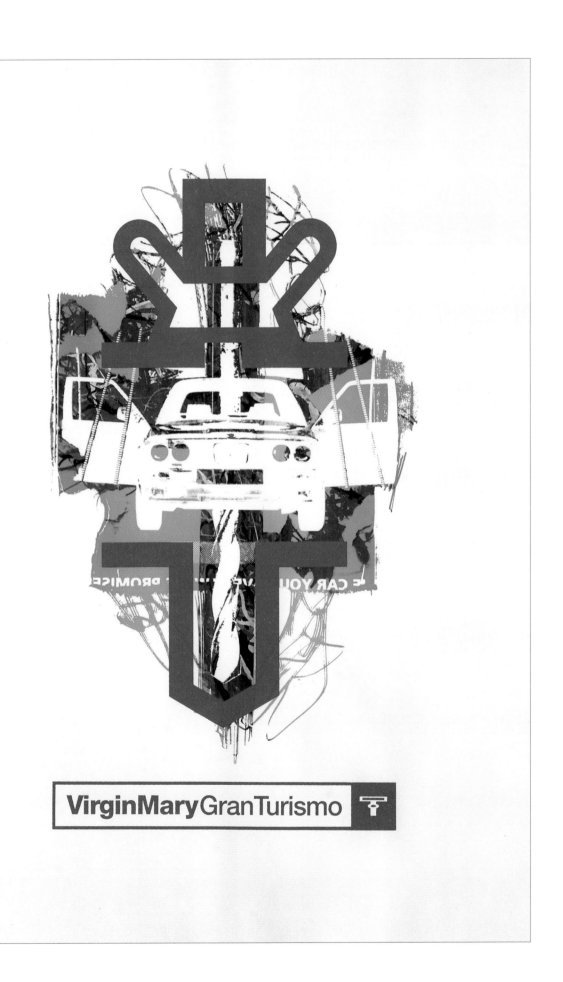

1 2
3 4

DAVID CROW:

Sometimes it's Difficult to Breathe
5760 x 2880mm UK 2001

Work in progress for a 20' x 10' public billboard project (2) entitled **Sometimes it's Difficult to Breathe**, constructed in 2001. This work was designed as part of a graphic arts project on the theme of public space and access.

Crow utilises a complex arrangement of different graphic elements, some scanned from old children's books or from contemporary newspapers and magazines (3). These are then combined with stencils and scans of found objects and rough hand-drawn marks and textures on paper.

Several images depict political figures from the British parliament, including Prime Minister Tony Blair, Chancellor Gordon Brown and the Opposition law and order spokeswoman Anne Widdicombe (3). These are scanned and given an extreme contrast, then reproduced as bitmap images on the computer. Notes in Crow's sketchbook (1) make reference to the political 'spin' in the British media and state "sometimes it's hard to breathe when the air is so full of [spin] lies." Early sketches (4) depict two figures in heavy

diving suits, surrounded by political and media figures in a thick smog. Crow's notes define the people depicted as coming from a range of characters, including "politicians", "ordinary Joes", "husband and wife", "soldiers" and "terrorists". He also suggests that the image might refer to marriage or the nuclear family.

The final piece (2) was digitally reproduced and collaged on a full size billboard by Crow himself. The air tank has now been transformed into an image of a butterfly set against a blue sky, which may symbolise both purity and the fragility of the fresh air away from the political and media machine.

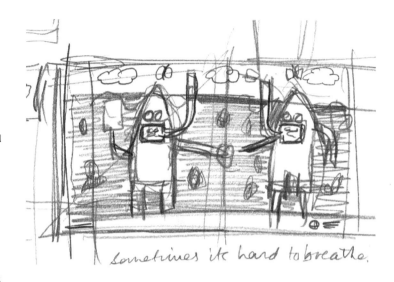

attitudes

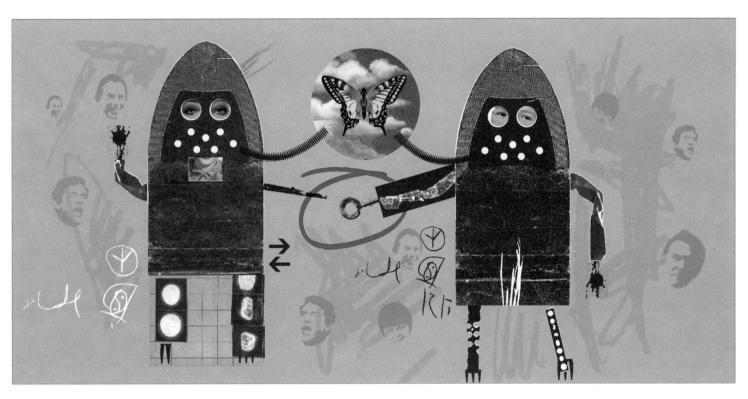

THE ITALIAN FOR POSTER IS MANIFESTO

Leonard Sonnoli (b. 1962) is an Italian designer whose prolific graphic output and poster design has been widely recognised in numerous exhibitions and lectures. A regular contributor to international graphic design forums, he was honoured with a one-man exhibition at the annual poster festival in Chaumont, France, in 2001, where he was also a member of the jury for the professional competition. His poster designs for the Italian Municipality of Pesaro show a sophisticated employment of white space and visual metaphor through the use of simple but elegant photographic compositions and understated typography. Self-authored posters in the 'Wri-Things' series show a personal concern with the written word and radical experimentation with typographic form.

How did your training as a designer influence you and your work as a poster designer?
I imagine by training that you mean my first experience of work and not my academic education. Anyway, in my case my first job was very important – not only as a way of improving my skills but mainly my cultural knowledge. I say this because the state of Italian design education within the universities is very sad. I find it quite hilarious, or maybe even tragic, that in a country so well known for its design of furniture, products, cars, and so on, only in the last few years have design faculties appeared and even now graphic design is still a small part of this. In short I didn't receive a good design education.

Luckily I began my real apprenticeship with Paolo Tassinari and Pierpaolo Vetta, who are the founders of one of the best graphic design studios in Italy – in my opinion. Through working with them I learnt the importance of design history and how to be more free in my work. I learnt to love the work of the modern European avant-garde who were the pioneers of contemporary design of which we are all now just 'colonisers'.

I'm not only a poster designer. My training was based on a whole range of different experiences – designing editorial layouts; catalogues, magazines and leaflets, as well as posters and

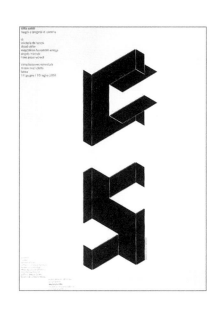

corporate identities. These days I'm also working on different design problems as well as posters. The most recent were a new architecture quarterly and a complete identity for an airport – including pictograms for its signage system. But I'm always very glad to have the opportunity to design a poster. Because I'm impatient and don't like to wait, posters are ideal – you have it all now, so to speak – they are very immediate for me. You have to solve the problem of synthesis, and try to capture people's attention whilst trying to visually explain the content.

Do you feel a connection to a particular tradition within poster design? Are there any particular influences on your work?
As I mentioned previously, the modern movement and the 20th-century avant-garde are, I believe, landmarks in the development of the subject and to a large extent my inspiration as a designer. These range from Italian futurism to 'Blast', from El Lissitzky to Jan Tschichold, from Tschichold to Piet Zwart and Otto Neurath to László Moholy-Nagy.

And of course the influence of the avant-garde in Switzerland; the Ulm school and later Wolfgang Weingart; in England from Anthony Froshaug to Hamish Muir; in the Netherlands from Piet Zwart to Wim Crouwel; and in my own country, Italy, from Studio Boggeri to Italo Lupi. But few things have made more impression on me than the book Malerei, Film, Fotographie created by László Moholy-Nagy whilst at the Bauhaus, in particular the extraordinary chapter 'typo-foto'.

I am interested in those design groups such as Pentagram and Total Design who pioneered corporate identity and a form of systematic applied design. Many years ago I was lucky enough to meet with Hamish Muir [of design group 8vo] in London. I showed him my work at his office and we spent some time together. At the time he was critical of my work and afterwards I became quite depressed, but eventually it helped me to change my work, I think in a much better way.

Were you given a 'free hand' in the design of the posters for the city of Pesaro – and were you asked to design the posters so that they created an identity for the city as well as its events?
The cultural department of the city of Pesaro wanted to commission a designer or design group for two years to promote the most important events that were happening in and around the city.

They were of course keen to save money and I believe found it easier to work with one graphic design office to establish and maintain a visual identity. I wanted to manage the whole project as a type of corporate identity but using posters! I think that my pluralist training helped me to think of the brief as a corporate problem to solve instead of just an opportunity to design many posters. At the beginning I didn't discuss this approach with the client because I wanted to find out how committed they were to the project. Eventually my brief became clear – to find a way to promote both the cultural events and the city of Pesaro.

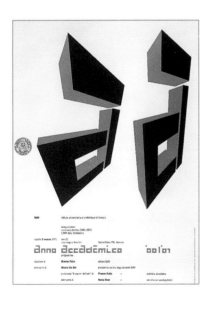

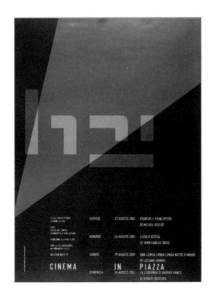

1 2 3 4

Leonardo Sonnoli
(1) Wolfgang Weingart lecture (2000)
(2) Città Sottili (2001)
(3) The Academic Year 2000-2001 (2000)
(4) Cinema in Piazza (2001)

Initially I looked for the graphic elements that would create this unusual corporate identity. I began to think that the way in which a person is recognisable – the visual appearance of their face, the way in which they dress and the phonetic aspects of their voice and its tone – could be applied to the design of the posters to create an identity.

I tried to use the same typeface in the same way for the information on each poster and to treat the main images in the same way – all based on Moholy-Nagy's idea of the 'typo-foto'. I tried to treat the graphic elements like a person's individual tone of voice.

Do you get much feedback or comments on your work from the public – the people of the city?
I don't live in Pesaro so it was not always easy to gauge people's reactions – occasionally I received compliments and sometimes negative comments, but it is interesting that often people would discuss my posters more than the events themselves. I began to understand that making a poster was in itself a cultural activity. I think that an effective or an experimental poster can enhance the visual culture of a people or place in some way.

Could you comment on the notion of authorship in connection with the 'Wri-Things' poster series?
I like to produce a poster for each lecture that I am asked to do, to leave something more than a souvenir behind – something

that develops the idea or the topic of the lecture. Don't forget that the Italian for poster is 'manifesto' and that this could also be interpreted as 'declaration' in English. So each 'Wri-Things' piece is a 'poster-manifesto'.

Each lecture is not just an opportunity to make a poster but a chance to reflect on my work and to try to produce something experimental. In the 'Wri-Things' series I like to play not only with letters but also with words. I attempted to invent a neologism – to explain the writing using things, such as objects and visual metaphors. I then tried to explain this in the Naples poster where I wrote 'displacement of types into things and things into words', quoting the work of the 'word sculptor' Lawrence Weiner.

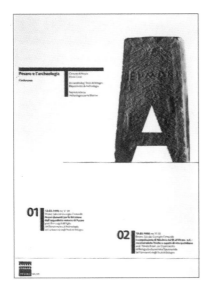

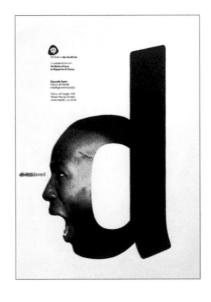

1 2

Leonardo Sonnoli
(1) Archaeology in Pesaro (1998)
(2) Diritti Doveri (1997)

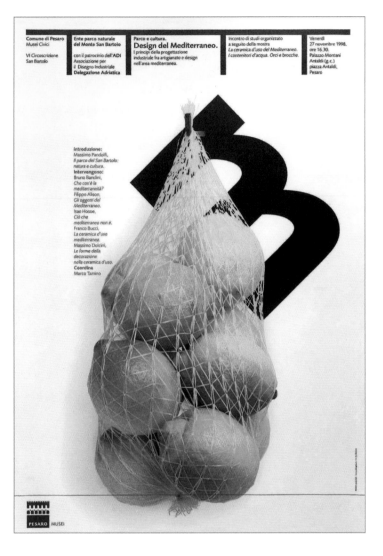

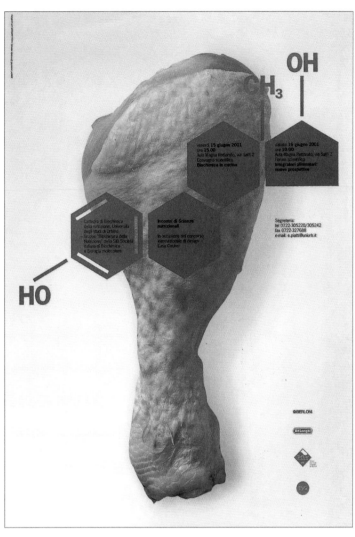

1 2

LEONARDO SONNOLI:
Posters
680 x 980mm Italy

Sonnoli's posters for the Italian city of Pesaro rely heavily on visual metaphor and strong photographic images, set against white space to present a sophisticated identity.

Design del Mediterraneo (Design from the Mediterranean) (1) uses a string bag of lemons to symbolise produce from the region, suspended on a metal hook protruding from a sans serif letter 'm'. This use of single letters is common to many of the posters designed by Sonnoli for the city, along with a distinct visual style which helps to create what the designer describes as "a type of corporate identity but using posters". In this case, the poster announces a series of lectures on the theme of Mediterranean design at the city museum in 1998.

Sonnoli continues to explore the central concerns of his work – the theme of 'typo-foto' and high quality production values – in the promotional poster **Incontri di Scienze Nutrizionali** (2) (The Science of Nutrition). This uses a strong photograph of an uncooked chicken leg set against a white background, and overlaid with metallic silver hexagons and details of the event. Large silver letters denote the chemical formula for the growth hormone – a critical reflection on the manipulation of animals in breeding and farming practices. The photograph is printed in full colour with metallic silver as a spot colour overlaid and type details in black.

> The poster designer often employs the strategy common to other areas of graphic design of using common elements in a sequence or series to reinforce a message or to establish an identity. This approach is utilised by editorial designers who design a system or grid to contain these common elements while allowing a flexibility of approach to the layout of information.

> This method of working enables the reader or audience to recognise (often unconsciously) key elements such as typeface or colour used in repetition across a range or sequence of pages. The audience becomes familiar with a particular visual approach, which gives the designer the freedom to unfold a message or body of information over a larger canvas than is offered by the single page or space. The same approach may be employed by the poster designer to create and reinforce a visual identity for a gallery, museum or an event. This is true of the work of the British design group 8vo for the Dutch Museum Boymans-van Beuningen in Rotterdam (pp58–59) and by Leonardo Sonnoli in his work for the Italian city of Pesaro (pp52–53).

Sequential Emphasis

> The poster designer may also explore the serial possibilities presented by creating multiple works to establish a single message, designed to be displayed together in one single location. In the work of David Tartakover (pp42–43) the same image of three generals – Dayan, Rabin and Narkis – entering the city of Jerusalem is presented on four posters commemorating the 30th anniversary of the occupation of the Gaza Strip in Israel. Each poster is progressively overprinted onto disparate found material – printers' make-ready sheets and films from commercially printed work such as property pages from newspapers and army manuals. The effect creates an atmosphere of claustrophobia, a shifting context for the image and (in the last poster in the sequence) its eventual obliteration. Tartakover builds upon the sequential reading of the same image by linking each poster with the repetition of three red crosses, again overprinted onto the image. This signifies a negation of the three individuals but also represents the 30-year occupation – each cross can also read as the roman numeral for ten.

Serial Evolution

> Studio Boot, based in the Netherlands, also explores the idea of a narrative created over a period of time, but in this instance that period is across a number of years. In the series of posters celebrating the theme of Chinese New Year (pp48–51) the designers adopt the same approach of an apparent 'low tech' production to achieve an unusual level of visual sophistication. In fact each poster utilises special metallic colours in addition to the four colour silkscreen printing. Key elements are repeatedly employed – in particular the aerosol spray paint and stencil effect and the use of a 'loose' paper label glued to the poster along only one edge. This method ensures that, while each poster is produced annually, when viewed collectively the visual sophistication of the designers and the quality of reproduction of their client, the Dutch printing company Kerlensky, can be appreciated.

Designs on Repetition

> Poster Series No.7 by the Association Commune (pp56–57) is comprised of nine linked posters that are intended to be displayed together in a specific sequence. When arranged in this way, they form a narrative that highlights the plight of asylum seekers awaiting judicial or government review in European detention centres. A symbolic borderline of crosses runs across each poster; this creates a divide between top and bottom on individual posters, but also serves as a device to link each poster together.

> While all the posters in the sequence are printed in black and white and utilise the same type family, the individual approach to each poster's layout varies in the amount of imagery or type employed by the different designers. It is worth noting that the sensitive use of space within individual posters also acts as a form of visual linkage. The use of the multiple to communicate a complex range of issues and messages is employed to great effect; the scale of the sequence of posters when viewed together creates an almost panoramic landscape echoing the issues of humanity, citizenship and media representation explored in the work. The visual language of black and white photographic images – in many cases appropriated from the media – and the hard-edged typography is exploited by the designers to create a serious or factual impression on the viewer.

Systems of Identity

> The posters commissioned by Wim Crouwel for the Dutch Museum Boymans-van Beuningen designed by 8vo (pp58–59) establish a visual system that both allows the designers the space to explore the themes and content of individual exhibitions and simultaneously to progressively 'brand' or create an identity for

the museum. The employment of repetitive devices such as format, type family and colour palette over an extended period of time (almost seven years) creates the effect of a familiar visual feel and in the process this becomes a significant element of the museum's public identity.

A Common Format

> Leonardo Sonnoli's work for the Italian city of Pesaro (pp52–53) works in a similar fashion to that of 8vo: by utilising a restricted colour palette – driven by a limited budget, and employing a consistent format – the designer manages to provide a sophisticated visual identity. Working with what Sonnoli describes as "the visual language of typo-foto" (p35), he is able to create a flexible system that allows the differing content of each cultural event, ranging from an exhibition of documentary photography to an exhibition concerned with kitchen design for disability, to create a cohesive family of posters.

> Much of Sonnoli's work is concerned with exploring the communication of ideas and messages in a sequential manner, either across a period of time as in the work for Pesaro, or to progressively establish a visual identity, each poster taking a common format designed to be seen in series – as in the 'Wri–Things' series of self-authored posters (pp112–113). Other work, such as posters for lectures by Franco Grignani and grappa blotto (pp114–117) utilises both sides of individual posters with the intention that both will be displayed together.

> Within both sequential and serial poster design, certain key devices are used to link the individual elements together. These might include maintaining a consistent colour palette across the range of work, as in the work of Sonnoli and 8vo. Other visual devices often include the repetition of formal elements or grid structures within the composition of each piece; similar printing methods and sizes; or styles of illustration.

Cost Limitations

> In some cases a limited budget can provide the brief or determine the working method employed in the composition of, or approach to, the design of a poster. The posters created by Studio Dumbar (pp54–55) for the Zeebelt Theatre in the Netherlands turn a limited budget into an asset; the same image created in a single, cost-saving, photographic studio shoot is then used and reused a number of times for successive stage productions. Each poster is produced by a different Dumbar designer by silkscreen overprinting the original image. Production costs are kept to a minimum as the initial full colour work is done as a multiple print run, and the designers are able to play with the self-imposed restraints in order to create new and imaginative compositions, masking out areas by overprinting colours.

An Accent on Theory

> A thematic approach can be seen in the work of design group Visual Research, based in the UK, for a series of self-designed posters advertising lectures given by the design partnership about their work (pp46–47). Employing similar devices to those outlined above of a regularised grid and a common type family across a series of posters, individual posters for each lecture and workshop explore the relationship between word and image and how these may be interpreted by the viewer. The posters do not seek to advertise the event by relating the content to the location of the talk, but are exploited by the designers to revisit a common theme in their own work concerned with communication between designer and audience.

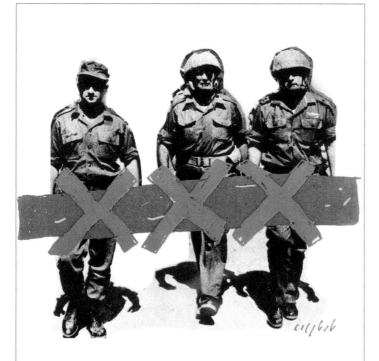
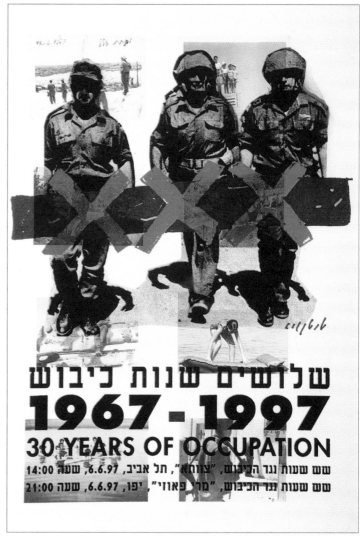

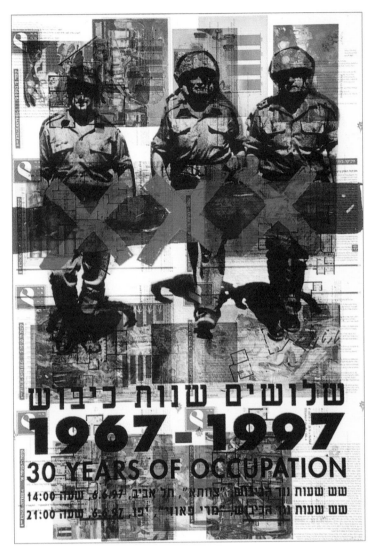 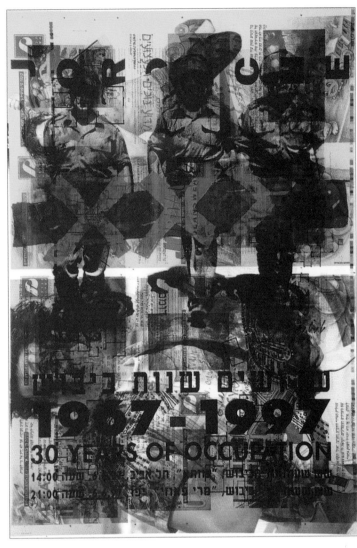

1 2 3 4

DAVID TARTAKOVER:
30 Years of Occupation
All 700 x 1000mm Israel 1997

This sequence of posters marks the 30th anniversary of Israel's occupation of the Gaza Strip. The photograph depicts a familiar image of Generals Dayan, Rabin and Narkis entering the old city of Jerusalem in 1967.

Tartakover self-produced the first poster (1) using offset litho-printing to produce a full colour image on a white background. The use of a coloured band across the centre of the poster, with three heavy red crosses overlaid, gives a sense of a dramatic barrier

between the viewer and the figures in the poster.

The resulting prints were then printed over newspaper and magazine images and printers' make-ready sheets from the Israeli press (2, 3, 4), giving the impression of an increasing density of information and a feeling of pressure or claustrophobia to the viewer. This could be construed as a comment on the political deadlock in the Middle East and the frustration of the Palestinian people in the occupied

territories. Like much of Tartakover's work, a sense of confrontation and political activism is very evident.

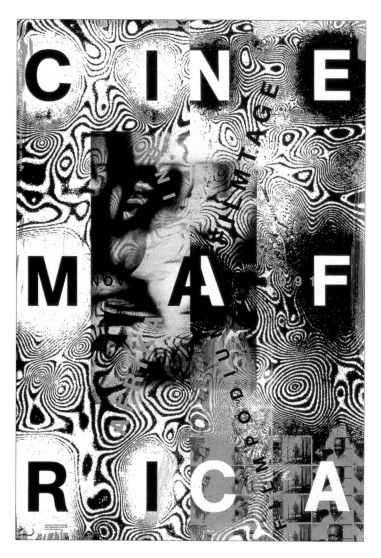

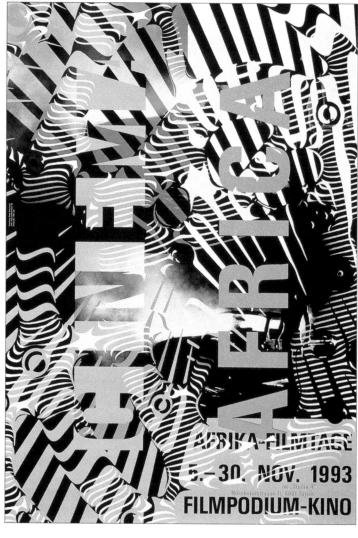

1 2 3

RALPH SCHRAIVOGEL:
CinemAfrica
All 905 x 1280mm Switzerland

This series of posters was designed by Schraivogel for CinemAfrica, a biennial African film festival in Zurich, Switzerland. The concept involved a limited use of print colours, each poster being silkscreen printed from camera-ready artwork, often using slightly transparent white as well as coloured inks.

The three-dimensional relief effects and moiré patterns were created by covering the artwork with plastic and overlaying a line screen. The resulting assemblage was then placed on a vacuum bed under a repro camera in the designer's studio and photographed by Schraivogel and Hugo Jaeggi.

This method embraces many of the technological aspects of the print process, together with experimental approaches to light and film, to create dynamic, beautiful and complex images. Many of these working methods can be seen repeated throughout Schraivogel's work, which often tests the limitations of the reproduction process. Examples of posters shown date from 1991 (1), 1993 (2) and 1997 (3). The posters show a thematic link across the series and a visual development from the use of photographic images within the composition (1, 2) to a more abstract typographic form (3).

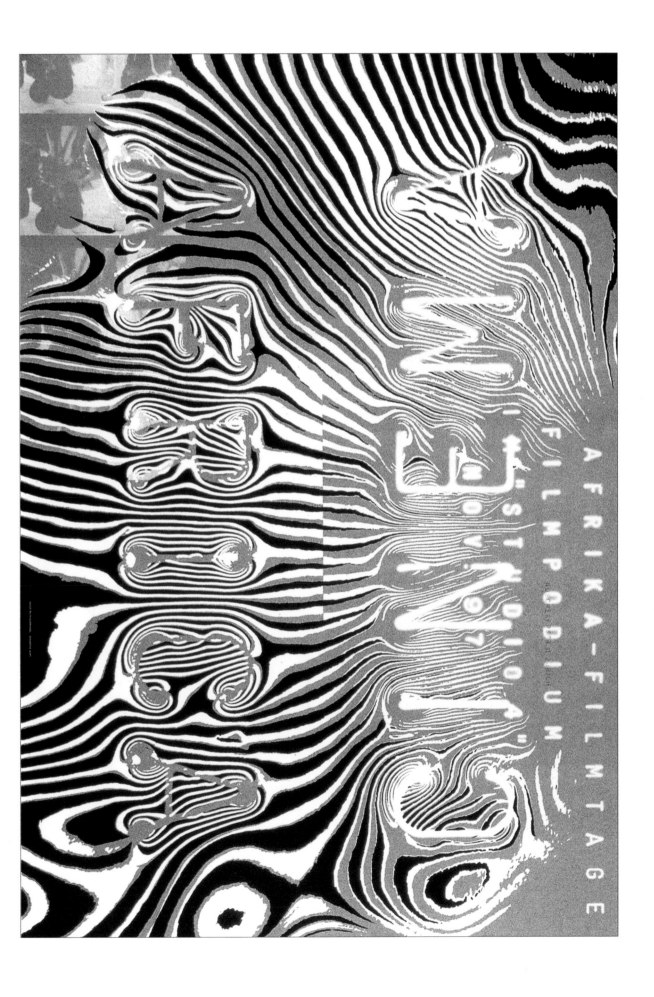

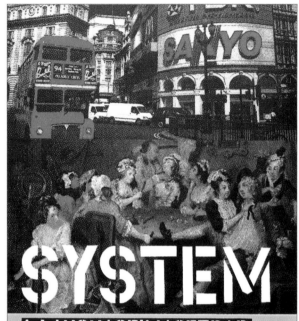

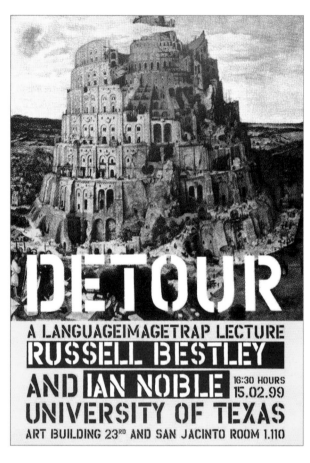

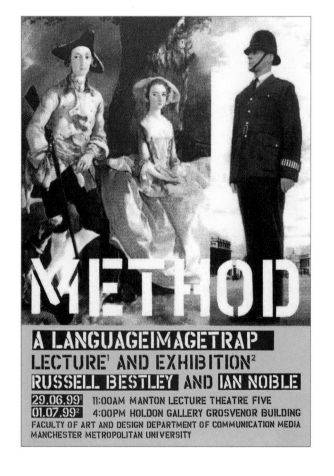

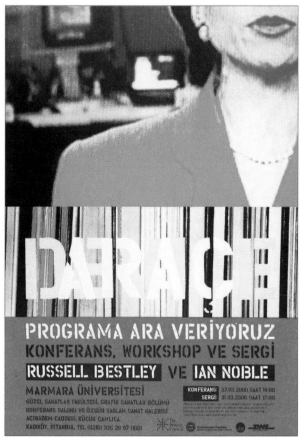

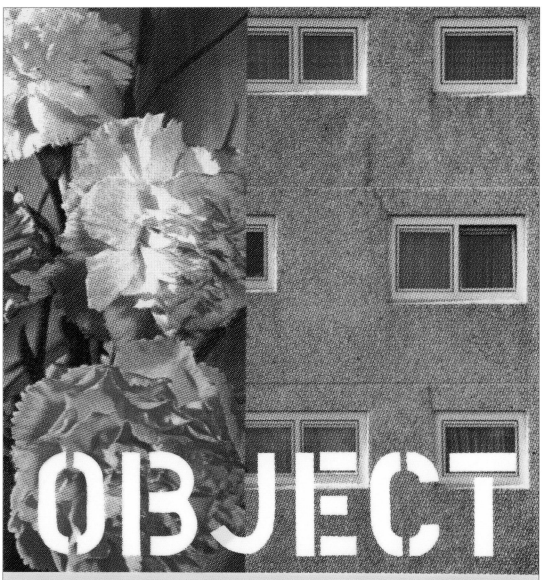

1 2 3
4 5

VISUAL RESEARCH:
We Interrupt the Programme
All 420 x 594mm UK
Sequence of posters promoting events for the design and education research project called We Interrupt the Programme (1999–2000). The posters attempt to offer visual and metaphorical clues to the content of the project itself, being designed to reflect individual locations and wider concerns. The first poster in the series, produced to promote a lecture at the London College of Printing, UK (1), juxtaposes an image drawn from a contemporary postcard of Piccadilly Circus, London (a clichéd depiction of the city) with a detail of a painting of 18th-century London life by Hogarth. As with each of the following posters (2, 3, 4, 5), a single word, in this case 'System', is stencilled across the poster. Each word functions as a counterpoint to the images, as well as being a key word significant to the wider project.

The poster designed for a lecture and series of workshops in Istanbul, Turkey (5) incorporated two languages, the word 'Device' overlaid with its Turkish translation. Images of a television newsreader and the page ends of books in a library allow the reader to make a connection between changes in contemporary media with sources of public information.

The poster promoting an event in Portsmouth, UK (3) incorporates an ambiguous keyword, 'Object', which may be read as a verb or a noun. This is set against images of a block of flats in the city and flowers taken from an old hand-tinted postcard – making an ironic distinction between the natural and the manmade.

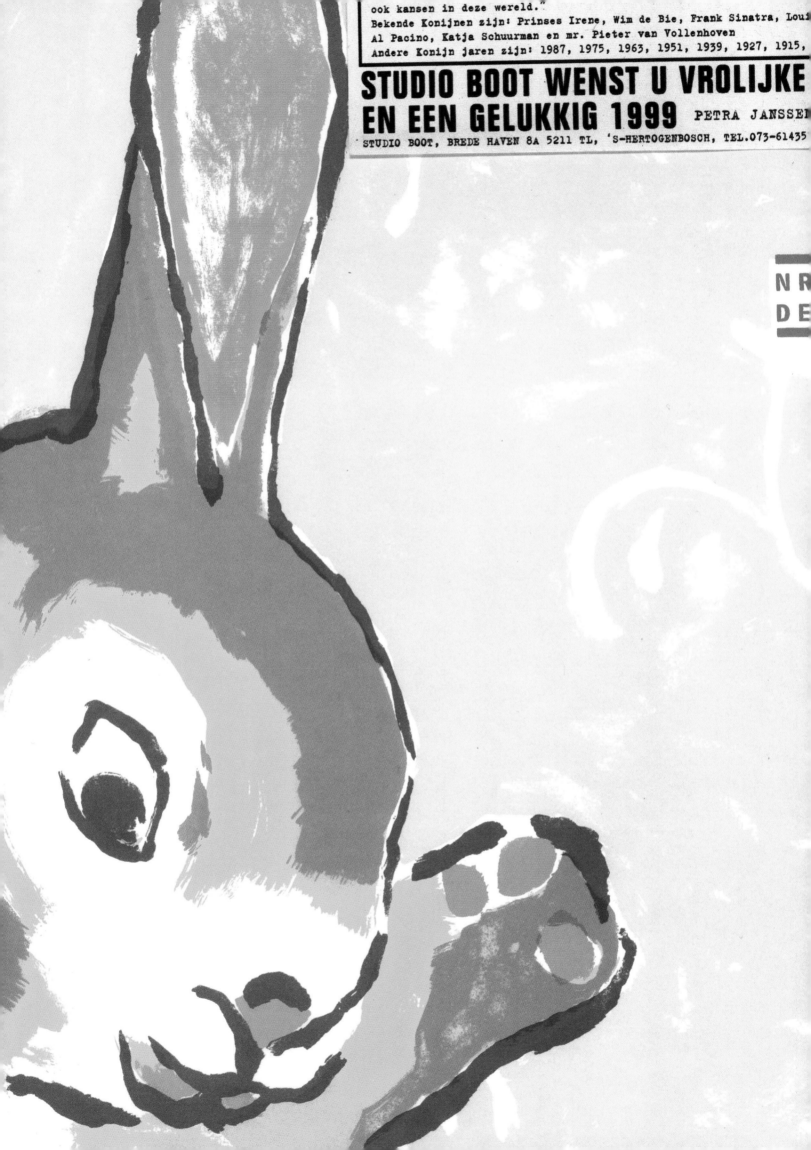

ook kansen in deze wereld."
Bekende Konijnen zijn: Prinses Irene, Wim de Bie, Frank Sinatra, Loui
Al Pacino, Katja Schuurman en mr. Pieter van Vollenhoven
Andere Konijn jaren zijn: 1987, 1975, 1963, 1951, 1939, 1927, 1915,

STUDIO BOOT WENST U VROLIJKE
EN EEN GELUKKIG 1999 PETRA JANSSEN

STUDIO BOOT, BREDE HAVEN 8A 5211 TL, 'S-HERTOGENBOSCH, TEL.073-61435

N R
D E

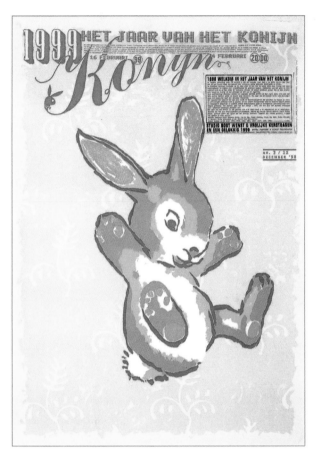

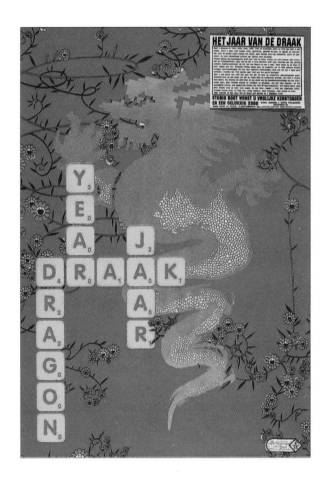

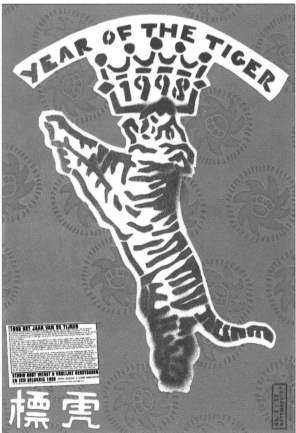

1 2 3
 4

STUDIO BOOT:
Chinese New Year posters
All 594 x 841mm Netherlands

Series of posters designed by Studio
Boot in the Netherlands, on the theme
of the Chinese New Year. Posters were
produced each year from 1996, and
were commissioned and silkscreen
printed by Dutch printing company
Kerlensky. Each individual poster
depicts the animal associated with the
Chinese calendar. 1996 (3) denotes the
Year of the Dragon, depicted by a full
colour illustration and accompanied by
text in both English and Dutch.

A similar theme is employed in the
following posters, from 1998 (4),
the **Year of the Tiger**, and 1999 (2),
the **Year of the Rabbit**. As can be seen
in the full-size section (detail 1), each
poster is produced as a four colour
silkscreen print with additional metallic
spot colours.

The posters are usually folded to A4
and mailed out to friends and relations.
A separate one colour label is attached
to each poster, glued along one edge
so as to remain partially loose. This
element adds a further layer to the
poster, and acts as a set of instructions,
giving details of the intention of both
the designers and the printer.

3 4

1 2

STUDIO BOOT:
Chinese New Year poster – 2001
Year of the Snake
594 x 841mm Netherlands

Work in progress for a poster celebrating the Chinese New Year 2001, the Year of the Snake. Preliminary pencil sketches (1) show the initial concept for the snake illustration, which is then reworked in a series of developmental sketches (2, 3). Coloured inks have then been introduced in a wide range of combinations and a variety of decorative additions have also been included.

The sketchbook work is produced with pencils and coloured pens, scaled down to fit an A4 page. The final design (4) is not taken to print until all elements have been resolved, including the formal composition of the work, range of colours and the layers of ink that will be required during the printing process. It was important for the designers to be fully aware of the printing process for the work, including its limitations together with any options available for the blending of colours, demands of registration etc.

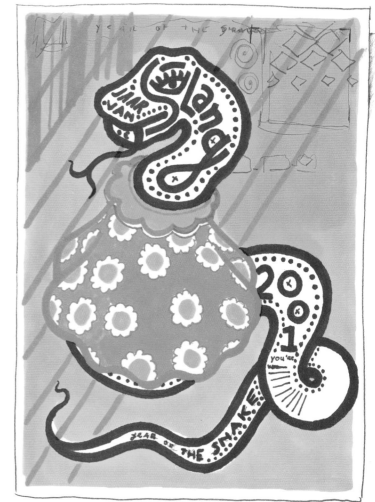

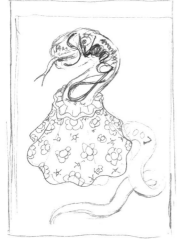

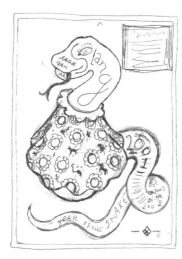

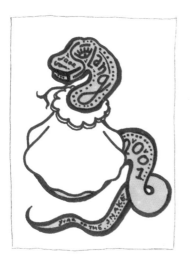

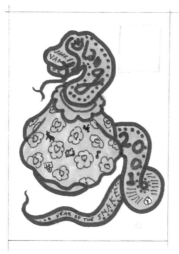

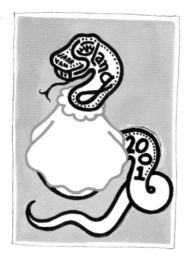

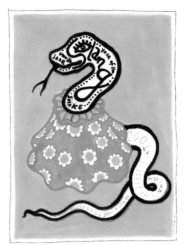

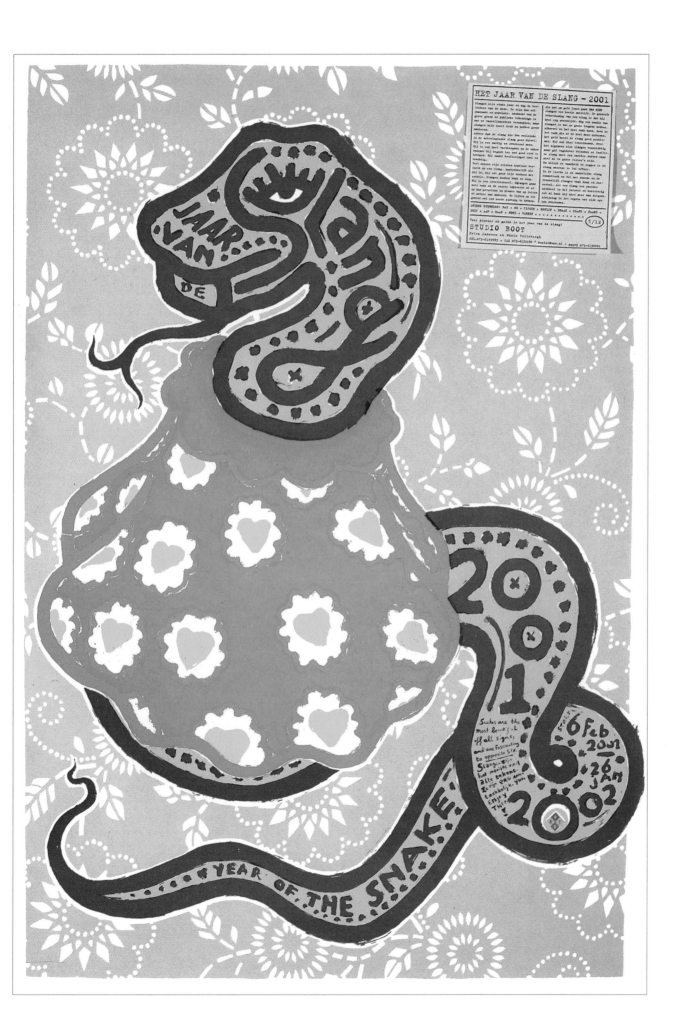

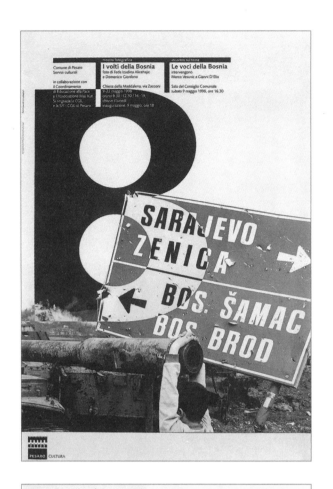

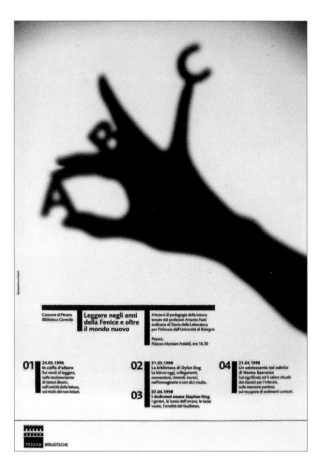

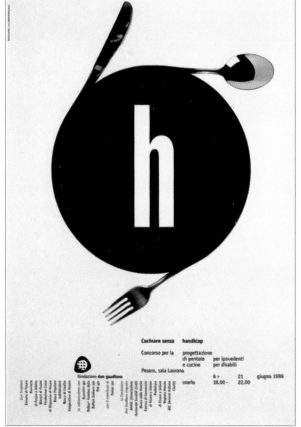

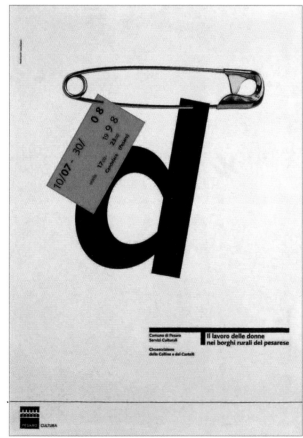

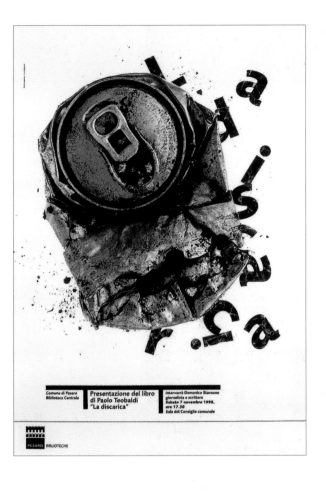

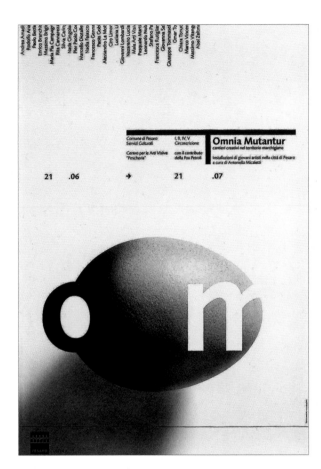

1 2 3 4
5 6

LEONARDO SONNOLI:
City of Pesaro cultural posters
All 680 x 980mm Italy 1998

Sonnoli produces posters for the Italian Municipality of Pesaro, based on the corporate identity of cultural events in the city. The designer states that the identity system is unusual, in that it is based on "the visual language of typo-foto (see p35) instead of the classical rules." Each of the posters centres on a variation of the photo/typographic theme, relating to a particular event.

Most of the posters were produced on a limited budget, and were offset litho-printed in one colour. **I volti della Bosnia** (The Bosnia Faces) (1) was designed for a photographic exhibition about the war in Bosnia, and utilises a strong central image of a child playing on a burnt-out tank in front of a heavily beaten road sign to Sarajevo. The large letter B, overlaid on the image and reversed out of the road sign, dramatically draws the viewer's attention to the poster.

Leggere negli anni della Fenice (Reading in the Fenice's Years) (2) again uses a strong photographic image of shadowplay by a silhouetted hand holding the letters A, B and C. The poster was for a series of lectures on children and children's literature.

La Discarica (The Dump) (3) is for a book presentation by the author of a novel entitled The Dump. Sonnoli uses a photograph of a crushed can as a metaphor for the dump, with the title of the novel shown in 'discarded' type around the image. **Omnia Mutantur** (All is Changing) (4) promotes a group art exhibition.

Some posters were produced in more than one colour, for instance **Cucinare Senza Handicap** (To Cook Without Handicap – a design competition on the theme of the kitchen and disability) (5), which was offset litho-printed in two colours plus a silkscreen UV varnish.

Il lavoro delle donne nei borghi rurali (Women's Work in the Rural Villages – an exhibition of rural fabric work) (6), was again offset litho-printed in two colours, making strong use of white space to emphasise the limited colour on the ticket, which is montaged safety-pinned to the letter 'd'.

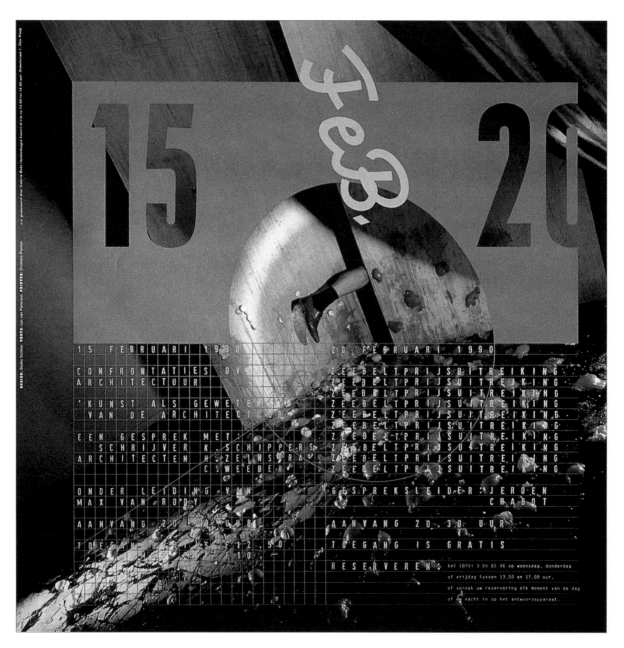

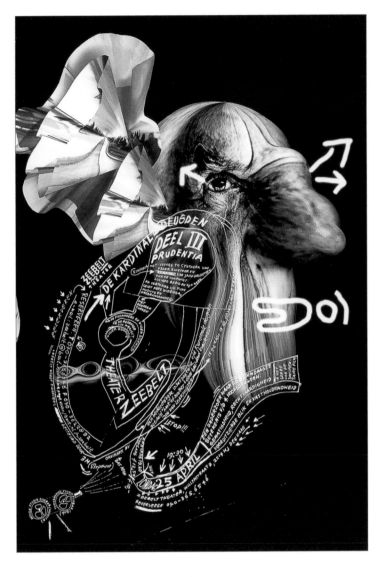

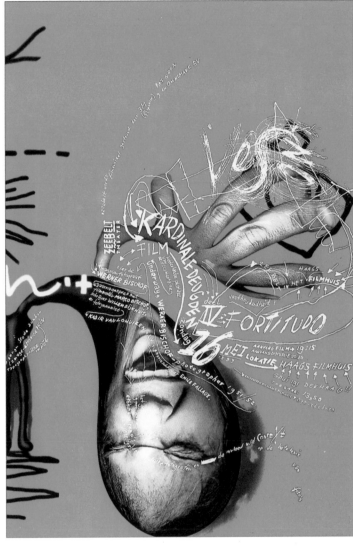

1 3 4
2

STUDIO DUMBAR:
Zeebelt Theatre posters
Netherlands

The poster and theatre programme designed by Studio Dumbar for the Zeebelt Theatre, the Netherlands, in 1990 was based on a central image of 'controlled chaos', which could subsequently be adapted and overprinted for future productions.

The designers produced a heavily constructed studio photograph for each series of posters for the theatre, which was then printed in full colour at a size of 600 x 600mm. The photograph, by Lex van Pieterson, apparently shows an actor disappearing offstage behind a door, while the stage itself appears to have been bombarded with raw eggs and tomatoes. On closer examination, the viewer can see that all the eggs have fallen on one side of a straight line, and all the tomatoes on the other.

Posters were overprinted with flat colours and type using silkscreen inks,

announcing a variety of events (1, 2). The posters show a tense and dynamic interplay between layers of images, textural elements and typography.

A series of posters for lectures about the cardinal virtues at the same venue in 2000 (3, 4) show the designers moving to a more illustrative style, again based on photographic images but with more abstract and hand-rendered elements overlaid. Text

appears scratched into the film, piercing the poster surface itself. The posters were litho-printed to a size of 500 x 707mm.

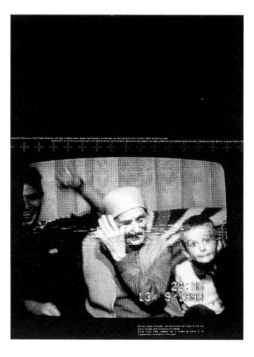

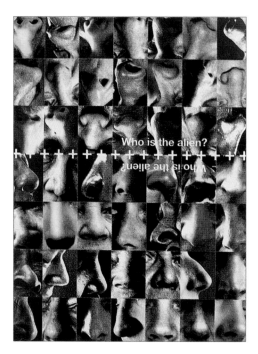

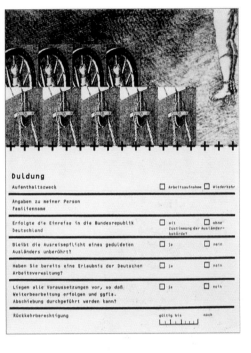
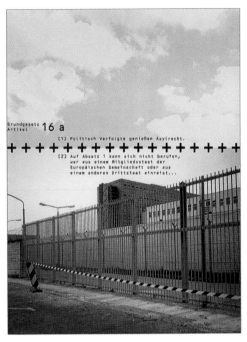
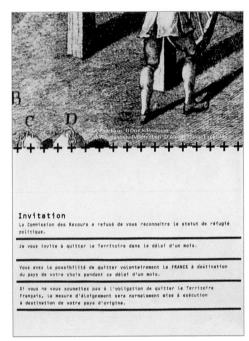

1 2 3 4 5 6
7 8 9

ASSOCIATION COMMUNE:
Poster Series No.7
All 584 x 775mm France 1997

This series of posters was created by
the Association Commune group at
Leipzig in the autumn of 1997. In a
similar theme to the **Toujours la
Même Histoire** poster (p27), the work
was produced collectively by the group,
and is a response to the deportation
process and European governments'
immigration policies.

Designed to be shown together as a set
in the numbered sequence shown here,
each of the nine posters was designed
by one designer or a small team.
Poster (1), designed by Claudia Heckel,
employs strong photography of a
television broadcast. Poster (2), by Uly

Felsing, is largely typographic, and
utilises the visual device of a row of
crosses to symbolise borders on a
map – a theme that is continued in
the other posters in the set. Poster (3)
was designed by Martin Klindworth,
again using an image as its central
foundation, in this case from an old
news photograph.

Posters (4, 6), by Katia Fliedner and
Nicola Meitzner, use a combination
of simple lines of text and repeated
images. The fifth poster in the set (5),
was designed by Conny Claus, using
a photograph of a detention centre.
The 'border line' in this case further

emphasises the fences surrounding the
compound, a method employed again
by Martine Derain in poster (8). Poster
(7), by Heike Burckardt, plays a visual
game with photographs of noses, and
poster (9), by Uly Felsing, Martin
Klindworth and Ruedi Baur, further
develops the metaphor of maps and
borders, ending the collective 'border
line' with a simple question mark.

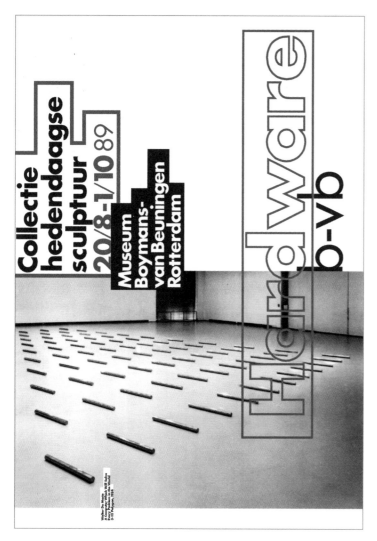

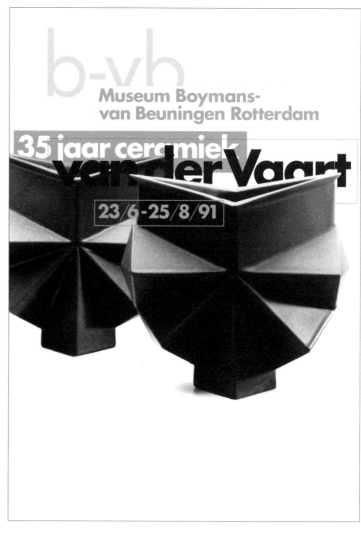

1 2 3 4

8vo:

Museum Boymans-van Beuningen

All 594 x 841mm Netherlands

The British design group 8vo were commissioned by Wim Crouwel, then director of the Dutch Museum Boymans-van Beuningen in Rotterdam, to design a series of posters reflecting a wide range of exhibitions at the museum between 1989 and 1994.

The designers constructed a visual system that incorporated a single type family – Futura – and allowed the construction of individual posters to reflect the composition of the photographs provided by the museum.

Litho-printed, often in a limited range of colours, the posters utilise white space and asymmetric sans serif typography to convey a high degree of sophistication.

Hardware (1), one of the first posters designed by 8vo for the museum in 1989, sets all type vertically against a photograph of a sculpture installation that displays a strong perspective grid. The poster marking 35 years of ceramic design by **van der Vaart** (2) places the ceramic pieces at the

forefront of a series of interwoven lines of type, giving further emphasis to the three-dimensional nature of the work.

Friso Kramer (3), created in 1991, announces an exhibition of industrial design. The designers again chose to allow the photographic composition to determine the form of the poster. The typographic information is presented in a series of lines above the seat of the chair – the type printed in three subtly complementary colours to emphasise the hierarchy of

information. This layering is again demonstrated in the last poster designed by 8vo for the museum in 1994, entitled **1928** (4). This exhibition marked the departure of Crouwel as director; the year 1928 marking his birthdate and the exhibits and poster images selected from events and inventions of that year.

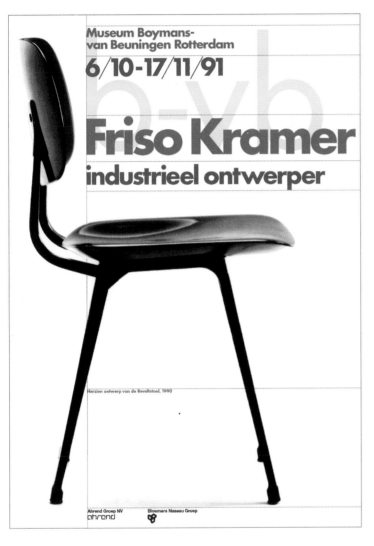

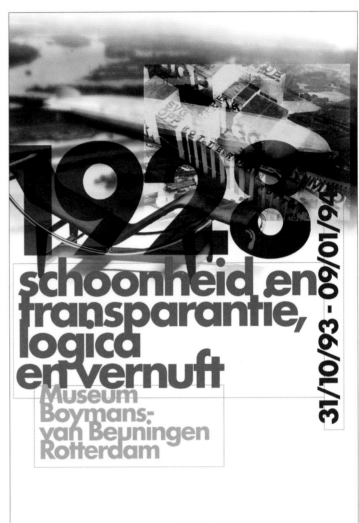

POSTERS SHOULD BE ABOUT UNDERSTATEMENT

Hamish Muir (b. 1957) co-founded the design group 8vo with Mark Holt, Simon Johnston and associate Michael Burke in 1985. Muir first trained in the UK and then at the Kunstgewerbeschule, Basle, with Armin Hofmann and Wolfgang Weingart. Between 1986 and 1992 the group published eight issues of their own journal of typography and design, 'Octavo', to critical acclaim from within the design community. Their work has become celebrated for its particular emphasis on typographic detail, eschewing decoration in favour of the use of sans serif typefaces and a simplicity and directness of communication. Their exploration of the limits of digital and printing technologies won many admirers within the international graphic design community and was to be a profound influence on successive generations of designers.

How significant is poster design to the work of 8vo?
The poster has always been central to the work we've done at 8vo – we always seemed to have a poster either on the go or just around the corner. I guess over a 15-year period we did, I don't

know, getting on for 60 posters. It's always nice to be working on or near a poster project.

You undertook a rather extended poster project for the Museum Boymans-van Beuningen in the Netherlands, when Wim Crouwel (Director) invited you to take over the design of the publicity for its exhibition programme. That must have presented you with a unique design opportunity?
If you look over the totality of the work we did, it was really a series of projects within a project. The format was set at A1, there were design issues such as having to use one type family, Futura, which we had never used before, and obviously we were working for Wim Crouwel, which in itself was an education!

I think it's interesting if you look at the posters and the way they developed over six or seven years. The first ones use quite tricky 'typo' detailing – we change the weight for the date, the year, etc. I remember talking to Wim on the telephone about the second poster and he said '...the type is small isn't it? The museum name

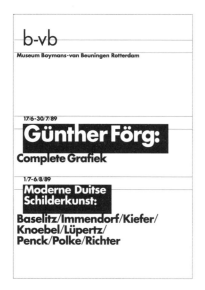

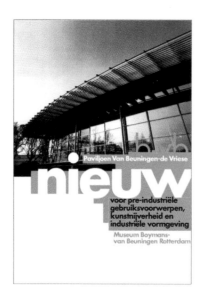

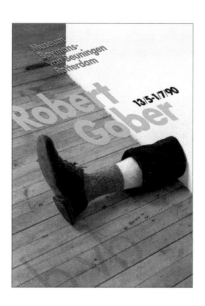

is a bit small?' And I said, 'OK, I'll make it five per cent bigger', and he said, '...no, no I meant bigger', and it ended up going up in size by about 25 per cent. I think it's interesting that whilst we were working on the first few posters we found out what he meant or understood by [a] poster; the conversations were always about simplicity and clarity.

Were you asked to create a visual system for the posters from the outset and was this linked to developing an identity for the museum?
Our approach was mutually agreed both amongst the group and with Wim Crouwel from the beginning – we wanted to reduce the amount of information used on each poster to the bare minimum. If you look at any of the posters made for the museum they would always carry roughly the same thing – all one would need really; the name of the museum, the name of the exhibition and any subtitle and the dates. They didn't bother about opening times, how to get there or concessionary rates – a small potted history of the universe for eight-year-olds or whatever.

Was the logo for the Museum Boymans-van Beuningen – B-vB – you employed on the posters part of the original brief as well?
The logo, also in Futura, became a kind of shorthand for the museum. The problem was that people referred to it only as the Museum Boymans, not the Museum Boymans-van Beuningen. The van Beuningen family were still actively involved with the museum, so it was to do with political sensitivity. We hoped

that using a more abstract mark would achieve a more equal weighting between the two halves of the name; I don't know whether it ever did or not.

Producing work that would appear in the Netherlands, where there is such a rich tradition of graphic design and poster design in particular, must have been a challenge?
I think that he [Crouwel] thought that by employing us we would offer an approach that wasn't based on a rigid system or repeated grid – that we would respond to the image and the information, always within the constraints of the common size and type family. I think the later posters start to work well in terms of the integration of type and image. We always felt that posters should be posters, not things that a gallery or museum should produce to sell in the shop. I think that in Holland in particular galleries and museums have recognised that a poster is a thing in its own right – as well as something to advertise an event and to get people interested enough to attend.

Many of the designers we have talked to while researching this book have said the same thing – that the poster is probably the closest thing designers have to art or painting. I guess that is why they are so beloved by designers, and maybe why they are prepared to go out of their way to do them, often for little or no fee?
Yes, later on at 8vo we would quite often pay for the printing of a poster – subsidising the client so to speak. We sponsored the Flux festival in Edinburgh, Scotland (pp106–107). Posters have always

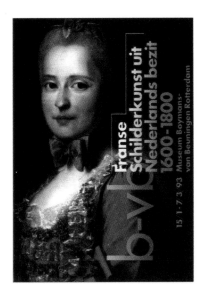
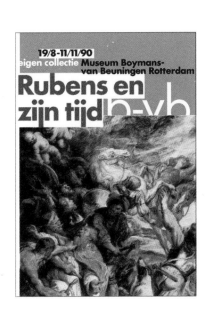

1 2 3 4 5

8vo – Boymans-van Beuningen posters
(1) Günther Förg (1989)
(2) Nieuw (1990)
(3) Robert Gober (1990)
(4) French paintings (1993)
(5) Rubens (1990)

been a great platform for designers to try things out, to express themselves – I don't think anyone really makes any money out of designing posters. They were a kind of therapy for 8vo – a playground, a chance to be more painterly – to enjoy the magic of working at a large scale.

There's no denying that big visual things tend to be more powerful than small things, especially in typography. Why do some designers insist on using small type on a poster when they have got acres of space to work with?

It's a design conceit about sanctifying white space I guess, unless you are designing them for your own wall. One of the lessons we learned whilst working in Holland was that you have to design posters to be seen with other posters. Often I think designers are only concerned with designing 'their' poster, they become locked into it.

Posters are great real estate for designers, very unique; this massive great piece of paper and loads of colours to use! I think that posters *are* the closest thing that designers have to painting. The opportunities to design posters are usually few and far between and often it may be the only one you do for a while or maybe even the last one you ever make, so you always want it to be the best thing you've ever done – to go out with a bang!

Conversely, working on the B-vB series we began to realise, after about a year, that we could be more relaxed about designing

each individual poster, and as a result we started creating better work. We began to see that we were designing a series and not a collection of one-offs. Also, I think we stopped designing for other educated viewers – by that I mean other designers – which I think is what a lot of designers do; and if I am honest it is always at the back of your mind, that you are designing for your fellow professionals.

It's a personal opinion, but I think posters should be about understatement; what I am trying to do with a poster is create a total visual environment, where people can 'get it' instantly when they see it. They might not get all the detail and all the levels of information, but the information should not overload the poster or the format. What I think is interesting about posters is that you can 'get it' instantly, yet if it's any good you keep going back to it, you keep wanting to look at it. In some way it's communicating on a level that transcends the information it's communicating.

One of the Haçienda posters you designed for Factory Records is very dynamic, using luminescent ink – was this an attempt to push the boundaries of the 'playground' as you described it?

With the Haçienda seventh anniversary poster (p105) we wanted to make a poster that responded to the environment in some way, that changed when it was rained on for instance. After talking about it for a few days we came up with the idea of using luminescent ink that would glow at night. Afterwards we talked to people who had left the club after the party at about

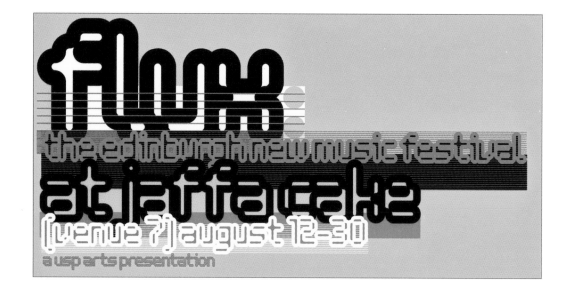

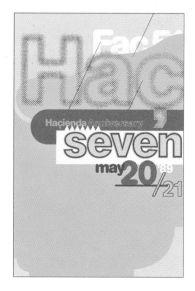

3am who said that there was a line of them pasted up and that they were glowing in the dark.

In design terms, it was probably the first real poster we had done. We worked on it for about four to six weeks and it had been through several different versions; we were making full size mock-ups and taking them onto the street to test them and getting more and more depressed. In the end, the starting point for the final design was a sketch scribbled in the back of a cab; just occasionally one suddenly 'sees' a design after weeks of effort.

It always appeared that 8vo had a very hands-on approach to designing. Was that true even after you got a computer in the studio?
Yes, before we got a computer we did everything by hand and usually at full size, even when working in a kind of shorthand on quick developmental sketches. When we did get a computer we would still 'tile out' each poster full size on A4 sheets of paper and stick them together by hand. We would also go out and track down the work when it was in the public domain and photograph it – just to see how this thing that we had lovingly treasured on the studio wall for four weeks would be seen after it had been folded and carried around in a bag and then pasted up with a dirty brush.

Part of me would like to be able to legislate for poster designers; and say for instance the minimum type size for an A1 poster should be 48 point – for two reasons: firstly as you get get older your eyes get worse, and secondly, what is it about graphic designers who want to make type which is so fucking small – even when they get a poster to do? The smaller the type, the easier it is to make it look good. I don't think people see the leading, spacing and kerning as crucial – it all becomes textural. 8 or 9 point type works very well in some reading situations, but try and handle 12 or 14 point within an editorial environment and you've really got to be good at what you do – it's quite hard.

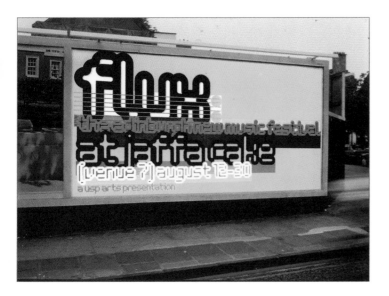

1 2 3

8vo
(1) Flux Festival 48 sheet billboard (1997)
(2) Haçienda Anniversary (1989)
(3) Flux Festival billboard site (1999)

> The poster has a particular visual power within the many forms of output available to the graphic designer. A large part of the poster's effectiveness resides not only in the scale of the medium itself but also the relative scale of the type and image employed within the frame of the poster. This chapter explores the use of image as the primary element within a poster design.

> The notion of image creation is a long-standing influence within the field of poster design, with designers constructing posters that communicate their message using a visual metaphor for a range of often complex issues and ideas. This distillation of an idea into a single image goes directly to the effectiveness of the poster as a medium for communication. In many cases the images employed have a universal understanding, such as in the work of Pierre Bernard (pp92–93). Other posters rely on the audience's familiarity with the context of the image for the work to be fully understood. The influential Polish poster designer Roman Cieslewicz stated that as designers we have a responsibility to find images that clean the eye. This sentiment is central to much of the work featured here – the individual designer striving to reinvent an image that, while familiar to us, is represented in such a manner as to make us reconsider what we feel or know.

Changing Contexts
> We are surrounded by photographic images in our daily lives and it is this familiarity that enables the designer to produce surprising effects in the eye of the viewer. By changing the context of an image the designer is able to let it communicate other meanings, which in turn shift an audience's perception of that image and enable understandings beyond the surface of the picture to emerge. Other poster designers employ a more basic approach – choosing to create images by hand and utilising a feeling of humanity in their poster design, which, while out of step with the contemporary plethora of photographic images, communicates by using another form of comforting familiarity.

> The poster created by the French designer Pierre Bernard (pp92–93) for the theatre play La Veuve (The Widow) builds upon our familiarity with a particular image. The designer, a founder member of the French collective Grapus, constructs a poster from a photograph of a woman's mouth, itself widely recognised as symbolic of language and love. By turning the photograph on its side in the final poster another, more subtle, meaning for the viewer is reached, that of sex and the female body – echoing the themes within the play. Bernard's poster designs, along with that of other members of the Grapus collective and the Atelier Populaire in France including Alex Jordan (pp90–91), Alain le Quernec (pp144–145) and Gérard Paris-Clavel, have become a significant influence on both poster designers and graphic designers in general over the last 30 years. Working collectively and individually, the group have produced award-winning posters for a range of clients including museums, galleries and theatres, but, importantly, all have chosen to concentrate their attentions on creating work dealing with social and political issues of the time.

Drawing Conclusions
> Alex Jordan (pp90–91), who also works collaboratively with Isabelle Jégo, Valérie Debure and Ronit Meirovitz under the title Nous Travaillons Ensemble, produces posters and a range of graphic material that also deal with social and political concerns. The poster called March '98: The French Right makes an alliance with the National Front uses an illustration of a hand that has a swollen and infected wedding finger caused by its ill-fitting wedding ring. This visual metaphor for the unfortunate marriage between French right wing politicians and fascist/racist extremists is more effective than a photograph would be in the same context. The hand-drawn style creates a more metaphorical image that helps to communicate a serious issue for European people and demonstrates a strong visual connection to the traditions of European poster design. In this instance a realistic photograph of a gangrenous finger would inevitably have repulsed the viewer and distracted from the message.

> American designers Nicky Bilton, Andrei Kallaur, Cristopher Garvey, Todd Anderson, Matthew McGuinness and Morgan Sheasby work under the title of The Visual Mafia (pp72–75). The group, who met while art students in New York, produce posters that explore and comment on contemporary American culture. The I Love Old NY poster is based upon a distressed image of Mickey Mouse. While Mickey Mouse has become synonymous as a metaphor for American cultural imperialism around the world, the designers employ the image in this context to make an observation of the progressive 'Disneyfication' of their own culture in Times Square in New York. Once the designers had created the poster it was flyposted around the area alongside James Victore's Disney Go Home poster (p72), which deals with

the same issue.

> A powerful visual image is employed by The Visual Mafia to comment on a high school shooting in Oregon, US. A familiar image of a rifle range target is slightly changed so that on second reading the figure can be seen as a student with a baseball cap and schoolbooks under his arm. This confrontational image subtly communicates by allowing the audience to decipher its meaning.

> The Polish designer Sebastian Kubica employs traditional techniques in the construction of his posters (pp80–83). Using hand-drawn and paper-cut shapes silkscreened in flat colour Kubica is able to address complex themes such as equal rights and violence towards children: the crude techniques create a direct visual language that reinforces the themes explored.

Image Manipulation

> Stefan Sagmeister's poster designed for the annual American Institute of Graphic Artists conference held in New Orleans has the theme 'the design of culture meets the culture of design' (pp68–69). The central image of a large headless chicken running around a field is a provocative visual metaphor for a conference attended by the nation's visual communicators. Sagmeister extended the idea by producing his own chicken-foot typeface, created in Photoshop. The reverse of the poster/broadsheet (p125) becomes another exercise in challenging the accepted conventions of the profession – the typography is based on Sagmeister's own handwriting and is arranged in such a manner as to become a form of almost disinformation design. The event had some 70 speakers over two and a half days in six different locations and, as Sagmeister states, "it became clear that this conference would be a happy chaos. I decided it might be more interesting for readers if the poster were also chaotic." A small handwritten note from the designer is included on the poster, which reads, 'message to our animal friends – no chicken was harmed in the making of this poster', going on to add in smaller type 'other than a delicious six-piece McNuggets we enjoyed while Photoshopping'. Posters for other AIGA lectures have allowed Sagmeister the opportunity to explore further visual onslaughts on taste and design conventions (pp123–127).

Photographic Reality

> Designers Koji Mizutani and Uwe Loesch employ photographic images in their poster designs in different ways. Japanese designer Koji Mizutani's two Come Together for Kobe posters (pp86–87) were produced to raise funds for the Kobe earthquake relief fund in 2000 and use powerful documentary images of the event as their basis. The designer then effects the images by cropping and layering the colour balances and drawing and scratching onto the negatives to evoke a feeling of being there in the viewer.

> Uwe Loesch utilises photographs throughout his work, in many cases with minimal amounts of typography used on individual posters. Two posters (p89) deal with similar themes of the German past: the poster entitled UberLeben in Krieg (Surviving the War) is a dramatically cropped photograph of a wartime bunker or shelter. Loesch echoes the brutal concrete architecture with minimal typography, which is chopped in half and arranged to follow the angular lines of the building. The final poster can be pasted around the corner of a building or wall – its design lending itself to be read in that way. The www.scheisse.de (www.shit.de) poster is in fact a billboard produced for a festival with the theme of 'visual irritation'. The manipulated image of Adolf Hitler, removed of his hair and moustache, is a metaphor for the rise of neo-Fascist propaganda on the internet – which often takes a less familiar form but has the same intention behind it.

> French designer Pascal Colrat employs a seductive image in his design for a poster for a Paris gallery (p76). This at first glance appears to be an advertisement until the viewer is able to read the small caption at the bottom, which simply states 'capitalisation'. The image can then be interpreted in a number of ways – the Parisians being able to read the contrasting visual metaphors of wealth and poverty in the dual image of the luxury car and the social housing block.

RRY!

WHY A HEADLESS CHICKEN? IS IT A METAPHOR FOR THE PROFESSION? SHOULD WE STOP RUNNING AROUND LIKE ONE AND SIGN UP FOR THIS VERY INTERESTING CONFERENCE? IS IT A VOODOO SYMBOL? ANTI TECHNOLOGY? WILL A MIXTURE OF TELEPHONE SCRIBBLES AND TURNING THE CENTURY ART BRUT REIGN

THE DESIGN OF CULTURE
MEETS THE CULTURE OF DESIGN

THE 1991 BIENNIAL Conference
of THE AMERICAN INSTITUTE
of GRAPHIC ARTS

NEW ORLEANS
LOUISIANA

RRY!
MAY 13-16 1991

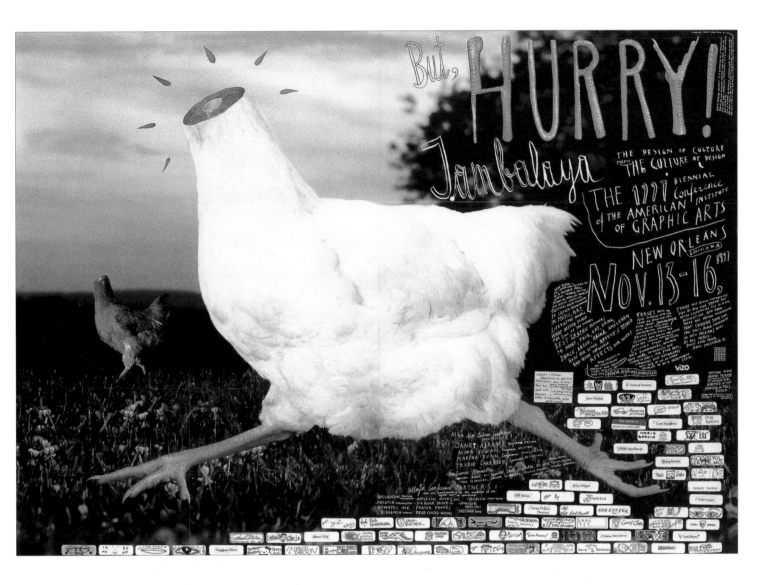

1 2

STEFAN SAGMEISTER:
AIGA conference poster
950 x 670mm US 1997

Sagmeister designed this poster as a double-sided broadsheet, including the conference information and speakers on the front (2) and the timetable of events and registration form on the reverse (p125).

Sagmeister decided to build on a metaphor of a headless chicken, reflecting the chaos that might be expected with such a large scale organisation of delegates and speakers across a range of venues. A mass of detailed information was provided for

the designer to incorporate in the poster, which Sagmeister chose to further emphasise by handwriting details on the poster reverse and adding further notes, short stories and asides.

The meaning behind the headless chicken is explored in handwritten notes in the top right of the poster (detail 1). Each speaker completed their details on a white label and these are collected and added in along the bottom of the poster (2). Most of the

text on the poster is hand-rendered – the main heading ('Hurry') formed of montaged chicken-leg letters. The assembled collage of illustrations and written information was then photographed and litho-printed in full colour.

1 2 3

PETER BILAK:
Paris Expo/Transparency
All 594 x 841mm Netherlands

Paris Expo (1) was designed for the Parc des Exposition in Paris, France, to promote its opening in 2000. Bilak designed a series of posters for the festival – this variation presents the Expo as a meeting space.

A full colour photograph of a crowd of people, viewed from above, dominates the poster. This dramatic image is overlaid with a simple typographic device incorporating two directional arrows meeting in the centre of the poster, and the caption 'Paris Expo:

Porte de Versailles'. Several other semi-transparent arrows are visible on other parts of the photograph, indicating movement and the directions of individuals within the crowd. The poster was litho-printed in full colour.

A poster announcing the publication of a book, **Transparency** (2) was part of a broad project that incorporated the production of a book (3), a website and a CD-ROM. Bilak states his intention with the project was to encourage the viewer to reflect on graphic design's

complex interrelationship to language: "[The book] Transparency is a study on design and language, discussing how to widen the gap in visual communication. Ideas are covered by its forms, which originally were to help to materialise the ideas. The book is not intended to romanticise graphic design, it is about provoking independent thinking."

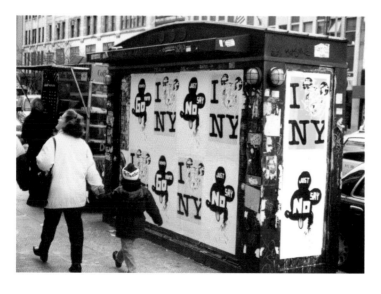

1 2 5
3
4

THE VISUAL MAFIA:
I Love Old NY
594 x 841mm US 2000

This poster was self-directed by The Visual Mafia as a reaction to what they term the 'Disneyfication' of Times Square in New York, US. The group – Nicky Bilton, Andrei Kallaur, Cristopher Garvey, Todd Anderson, Matthew McGuinness and Morgan Sheasby – were all art students who shared a studio in midtown New York. The poster takes as its central image a defaced image of Mickey Mouse (1), which was then sketched (2) and developed into a silkscreen poster with the addition of a simple typographic message (5). The posters were then flyposted in the area around Times Square (3).

1 2 6
3 4 5

THE VISUAL MAFIA:
New York posters
All 594 x 841mm US

The first poster produced by The Visual
Mafia, **Oragun** (1) was conceptualised
on 21 May, 1998, when a student went
on a shooting rampage at Thurston's
High School in Springfield, Oregon,
US. The boy killed his parents and
one other student, and injured 23
others in an act of violence that
shocked the nation.

Early sketchbook roughs (3, 4, 5) show
the development of the concept for the
work. The poster took only three days
from design to public presentation. The
designers state that the primary goal
of the poster was to call into question
the role of the high school student in
contemporary American culture.

The idea for the **On Duty** poster (2)
came about during the summer of
1998, when New York Mayor Giuliani
introduced new laws that were seen
as catering to the wishes of the more
affluent New Yorkers at the expense
of blue-collar workers such as food
vendors, cab drivers and street artists.
The poster shows Mayor Giuliani's face
defiantly obliterated by a hot dog.

The **Parisian Post** (6) is a personal
response by the group to a visit to
Paris, France. The group state that
they didn't agree with Parisian
tourist guides, and responded to
the culture clash with a very direct
visual message.

CAPITALISATION

1 2 3 4

PASCAL COLRAT:
Paris cultural posters
France

Capitalisation (1) was produced for the gallery RE PARIS, France in 2000, and is litho-printed to a size 1200 x 1760mm. Colrat was responsible for the design and photography, which offers a subtle critique of capitalism and wealth through visual metaphor within a complex image.

The full-bleed photograph displays a reflection of buildings in a highly polished car bonnet. The fact that the building is a typical Parisian housing block usually associated with poorer tenants, and the car is an expensive Mercedes, allows the intended viewer to read a discordance between the two elements. A simple red strap-line at the base of the poster gives a one-word context for the image – 'capitalisation'.

Aragon Dance (2) is a smaller poster and press announcement for an event at the Aragon cultural centre, 2001. Offset litho-printed at 200 x 300mm dimensions, the work again features Colrat's design and photography. In this case, an image of a road sign just outside the town is manipulated to direct drivers to the theme 'dance'.

ACT UP (3) was designed for the AIDS awareness group of the same name in 2001. Again using Colrat's own photography and design, the poster was offset litho-printed to a size of 500 x 707mm. A strong image of a blurred figure pointing a shotgun directly at the viewer gives a frightening visual message about the dangers of the spread of AIDS.

The **Traffic Lights** poster (4) was produced for the gallery RE PARIS in 1998, and features a photograph of traffic lights manipulated to indicate three green lights. Measuring 800 x 1200mm, this simple device offers a range of interpretations, relying wholly on the discontinuity within a usually familiar image. The image was later reused by Colrat on a poster for the French Communist party.

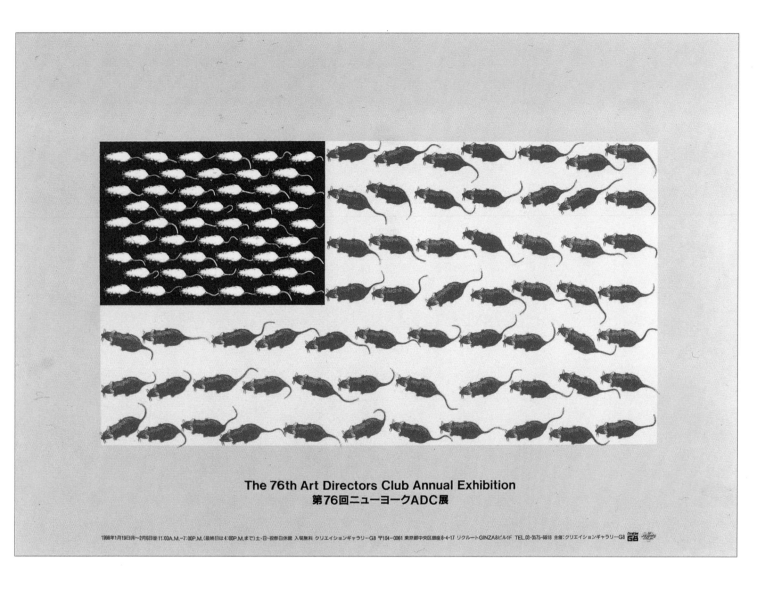

The 76th Art Directors Club Annual Exhibition
第76回ニューヨークADC展

1998年1月19日(月)～2月6日(金)11:00A.M.～7:00P.M.(最終日は4:00P.M.まで)土・日・祝祭日休廊 入場無料 クリエイションギャラリーG8 〒104-0061 東京都中央区銀座8-4-17 リクルートGINZA8ビル1F TEL.03-3575-6918 主催:クリエイションギャラリーG8

1 2
 3

MASUTERU AOBA:
Art Directors Club Annual Exhibition
1450 x 1030mm Japan 1998

Aoba designed this screenprinted poster for the 76th Art Directors Club Annual Exhibition in 1998 (2). The poster is printed in seven colours, with a flat base colour printed behind each mouse to give a stronger depth to the image (detail 1).

Aoba began work by collecting both stuffed (real) mice (3) and rubber moulded mice, which were then photographed and laid out according to a grid. He visualised the American flag in this way, making a reference to the client group and linking the large group of artworkers exhibited together, symbolising a movement.

1 2 3 4

SEBASTIAN KUBICA:
Stencil screenprinted posters
All 700 x 1000mm Poland 2000

Kubica works in a very traditional manner of poster design, using paper stencils to create screenprinted posters that incorporate bold, flat colours and strong images. The posters reflect the designer's concern with social issues, and the work was commissioned by Bielslio-Biata for local municipal use in public campaigns.

Poster (1), entitled **Graduate** shows a figure mounting a staircase, the higher steps of which feature sharp spikes, showing the dangers ahead for the climbing figure. **150** (2) again uses a very simple paper-mask screenprint, while **One x No** (3) utilises subtle printed textures and simple line drawings set within four white squares to draw the viewer's attention to a message about recycling materials.

Equality of Rights (4) again employs extremely simple forms to ironic effect. In this case, flying figures of men are juxtaposed with a woman, but she has a ball and chain attached to her leg, pulling her down and holding her back.

This presents a very direct message through the simplest of means, the words simply giving a context to a striking image which communicates as a visual metaphor in its own right.

MŁODOŚĆ STAROŚĆ

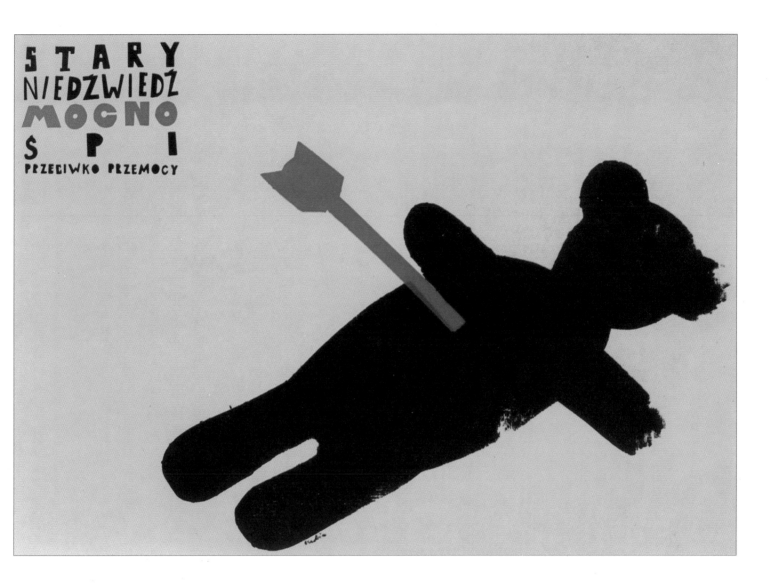

1 2

SEBASTIAN KUBICA:
Stencil screenprinted posters
All 700 x 1000mm Poland 1999

Kubica continues the working method shown on the previous spread in these two posters, reflecting themes of ageing and violence toward children.

Youth, Ageing (1) is another example of a very simple one-colour stencil silkscreen print, playing with the notion of time and showing a figure with a pendulum as a metaphorical heartbeat. The pendulum swings from 'youth' to 'ageing', then stops in the third figure indicating the end of life with the figure encased in a coffin.

Against Violence (2) was produced for the Polish town of Katowice, and centres on the problem of violence against adolescents. Kubica states that, "by using the easiest means, I want to show the existing problem; mostly a social one." Here, a child's teddy bear has been shot with an arrow, the flat red and black colours adding to the strong image. Kubica also designed the type on the poster using paper masks.

IBM分散ストーレッジ管理 (ADSM)
AdStaR® Distribution Storage Manager

なくしたファイルほど、悔しい。

1 2

KENZO IZUTANI:
The Lost File is Very Vexing
1030 x 730mm Japan 2000

Produced for IBM computers, this poster was offset litho-printed. The poster utilises an original illustration that depicts an office worker being comforted by colleagues, apparently (the viewer gathers from the small text) because of a mislaid digital file.

Izutani states that he wanted to design a poster that had the feel of an old cinema poster from the 1950s, as a direct contrast to the usual very modern-looking advertisements for computer technology.

After sourcing a variety of imagery on the theme of offices and figures from the 1950s, Izutani commissioned an illustrator to draw the scene for the poster and then drew in the computers in a very dated style (as desktop computers obviously were not invented in the 1950s). He then scanned the image and adjusted the colour balance to look more like an old cinema poster, and added text and captions.

As the poster was commissioned by IBM computers, and the workers are surrounded by desktop machines, the inference is that IBM computers might help to solve the problem. This is an ironic and amusing use of imagery – on first encountering the poster, the viewer might be led to assume that a serious tragedy has occurred in the life of the central figure. When the accompanying text is read, however, the poster delivers a witty but informative punchline.

COME TOGETHER for KOBE

1 2

KOJI MIZUTANI:
Come Together for Kobe campaign
1456 x 1030mm Japan 2000

Two posters produced by Mizutani for the Kobe earthquake relief fund. Both posters utilise powerful photographs of collapsed architecture following the earthquake, treated in such a way (through the use of lens flare and strong colour casts, for instance) to give a sense of urgency to their documentary nature. Mizutani then scratched directly onto the negatives to add to the dramatic image, further heightening the sense of distress and disturbance portrayed. The use of a diagrammatic bird as a typographic motif references the dove as a metaphor for peace and harmony, further emphasising the posters' call to 'come together' in support of the relief fund for victims of the tragedy.

1 2 3 4
 5 6

UWE LOESCH:
Posters
Germany

Immer nur Hächeln! (Always Panting!)
(2) was designed for the Foundation of
Art and Culture of the State of North
Rhine-Westphalia, Germany. Based on
an image of a rug (1) found by the
designer on the wall in the head office
of a printing company, the woven
pattern depicts a German Shepherd
dog, which Loesch asserts is culturally
associated with Germany's right wing
past. Loesch photographed the rug,
placing it centrally against a white
background. The poster's typographic

information was added, surrounding
the image and set at slight angles to
the vertical and horizontal. The final
poster was silkscreen printed in full
colour at a size of 1190 x 1750mm.

Again deriving from the theme of the
Second World War, the composition of
the poster **UberLeben in Krieg**
(Surviving the War) (4) is based on a
photograph of a wartime shelter (3).
The strong angular photograph is
complemented by Loesch's use of type,

which is dramatically cut into two
sections following the edges of the
building. Offset litho-printed at a size
of 841 x 1189mm, the poster can also
be pasted around corners, highlighting
the angular image still further.

www.scheisse.de (www.shit.de) (6)
was produced as a large scale
billboard poster for the German City
of Mönchengladbach, as part of an
international art festival on the theme
of 'visual irritation.' The message of the

poster was "to attack the propaganda
of neo-Fascists on the internet", and
the central image is of Adolf Hitler (5),
digitally manipulated to remove his
moustache and hair.

ÜBI
LEB
KR

Kriegserfahrung
1939 bis 1945
Ruhrlandmuseu
im Museumszer
Goethestraße 4
vom 19. Novem!
Dienstag bis So
Donnerstag bis
Montag geschle

ER
EN IM
IEG

en im Ruhrgebiet

m Essen
trum

ber 1989 bis 4. März 1990
ntag 10 bis 18 Uhr
21 Uhr
ssen

1 2 4
3

ALEX JORDAN:
Anti racism posters
France

Designer and educator Alex Jordan works collaboratively as part of the group Nous Travaillons Ensemble, based in Paris, France. This collective, including Isabelle Jégo, Valérie Debure and Ronit Meirovitz, work to produce posters and other graphic material to highlight the inequalities of European society and to progress the rights of groups who would normally have no public voice.

This work is produced in the traditions of European poster design linked to the social and political concerns of the left wing. It has a strong connection to French design groups such as Grapus, of which Jordan himself was a member along with Gérard Paris-Clavel, François Miehe and Pierre Bernard (pp92–93). Grapus had its origins in the Atelier Populaire of 1968. Posters such as **Europe against racism** 1997 (1) and **March '98: The French Right makes an alliance with the National Front** 1998 (4) are attempts to raise awareness of the increase in interest in extreme right wing politics in Europe. The posters are litho-printed on a large scale – **Europe against racism** measures 1200 x 1760mm, and **March '98** 600 x 800mm.

A similar illustrative style is used by Jordan on the **Trade Fair** posters 1995 (2) and **Barbarism or Algeria?** 1997 (3), measuring 1200 x 1760mm and 800 x 600mm respectively.

Barbarie ou Algérie?

mars 98 : la droite française fait alliance avec le Front National

1 2 3

PIERRE BERNARD:
Cultural posters
France

Two posters reflecting the work of Pierre Bernard, both of which show characteristics of the French illustrated tradition in poster design. The poster for the 2000 **Orléans Jazz Festival**, in the centre of France, (2) is silkscreen printed in full colour, 1200 x 1760mm, and shows a playful use of the photographic image as metaphor.

The hand appears to represent the playing of a variety of instruments – saxophone, piano and trumpet, for instance – while at the same time it attempts to capture the delicate swirls and marks that make reference to the music itself.

The central figure of the hand is surrounded by small, playful marks and illustrations (detail 1). These sometimes echo the hand-rendered marks on the photograph such as the instrument keys on the third finger, while at other times they appear more random – for example, the technical diagrams of a photocopier and an aeroplane, or the childlike line drawings of animals.

An earlier poster for the play **La Veuve** (The Widow) at the Theatre de l'Athenee in 1990 (3) was designed by Bernard and the Atelier de Creation Graphique Grapus in Paris. Again featuring a strong central photograph that has been manipulated by hand, the poster is offset printed in four colours, at a size 1005 x 1500mm. The play was written by Pierre Corneille (1606–84), and Bernard states that the poster "evokes the freshness and the loves of a young widow and expresses the very contemporary quality of the classical French language used in this play."

POSTERS –
NO COMMERCIAL VALUE*

David Tartakover (b. 1944) has operated as a graphic and poster designer from his studio in Tel Aviv, Israel, since 1975. His work has a particular emphasis on culture, often reflecting upon contemporary events within Israel and the occupied territories. David also works as a Senior Lecturer at the Bezalel Academy of Art and Design, Jerusalem, and maintains a research archive on the history of Israeli graphic design and ephemera.

A lot of your work is very topical and is a fast and direct reaction to events in Israel, where you live and work. How would you describe what you do?
My work is a kind of a seismograph, an attempt to record political and social events in Palestinian and Israeli life. The conflict in my country has been going on for the last 25 years, since the Six Days War. The only thing that I feel I can do is to try and evoke that tension and make people think through my posters. Most of my posters are produced and financed by myself. This is alongside other work that I make in my studio. The problem for me is not to make the work but how to distribute it so that it can be seen.

Most are made in black and white and are cheap to produce; often I will use xerox [photocopies] and they are made on the same day. For me it's a remedy, a kind of medicine. It's my duty as a citizen to try and do something. It is what I have been trained for – communication.

Is your professional training used in a meaningful way by doing this?
Yes, instead of selling my work I am giving it for free. Because I believe in the cause it doesn't allow me to make money out of it. You have to contribute something. This is what I do.

In the West we might assume that this kind of dissenting voice would have to be made in opposition to authority. Is the work displayed on publicly licensed sites on the street?
Some posters are displayed on the streets, as it depends if I get support from particular groups – sometimes they will finance it. There is one thing you can say about Israeli democracy and that is the right to freedom of speech, there is no censorship of what I do, even by the government. For instance, when my work was

displayed in the National Museum in Jerusalem the Israeli parliament asked questions about how someone who did the logo for the Peace Now movement could have their work displayed in a National Museum. I don't get much work from government departments or agencies but that was a decision I made – to work with cultural concerns.

Do you get much feedback from the public on the work you produce?
Sometimes – people write to the daily newspapers about it or there is an article published. When I made the United Colors of Netanyahu poster (p140) there was an article published in a newspaper analysing the work in detail. I also used to have a weekly column in a local Tel Aviv newspaper which rapidly reacted to the week's events through a combination of text and image. I really liked doing it... I did it for three years, before the deadlines and pressure of having to be alert all the time became too tiring.

That's an interesting extension of your work as a poster designer. Could this be described as visual journalism?
Yes, that's a good description of what I do. I believe this is my duty as an artist and as a designer – to react. There is nothing else I can do but to make people aware, to make people think. I don't believe you can change that much with a poster. To really change opinions and attitudes you would need millions and millions, which I don't have. For me it eases the pain and the pressure to make the work. Any voice helps.

Do you feel you have a personal connection to any particular tradition within poster design?
I feel connected to the Russian avant-garde movement of Constructivism in the early-20th century, and to Pop Art in the US and Europe in the 1960s. Those are the two biggest influences on my work. I am a one-man operation. I don't think about style and I don't think about decoration. I never bother about design really.

For me the ultimate poster or image that I could ever make would be summed up by the image I used for the poster entitled Freehand Design (p141). This is a news photograph of Mordechai Vaanunu, who today is in prison for revealing Israel's atomic secrets. In the picture he is being driven to court under heavy escort, and he is pressing the palm of his hand against the car window so that it can be seen by the waiting press journalists and photographers. Written on the palm of his hand with a black marker pen was the date and place of his kidnap by Mossad [Israeli secret service] agents – this information was prohibited by the Israeli government of the day.

Vaanunu acted just like a visual communicator; he was able to transmit a direct message in 'real time' to the media. He did not use ornamentation or decoration, he did not hesitate about which typeface or letterform or colour to use or in what format. As a graphic designer practised in the creation of visual messages, I wish that I could produce a poster that captures all of this.

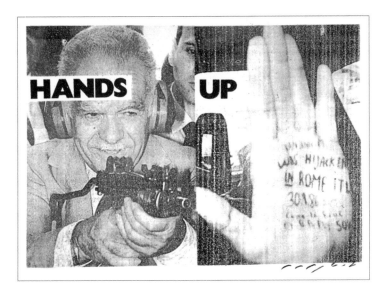

1 2 3 4

David Tartakover
(1) 25 Years of Occupation (1992)
(2) Evacuate the Settlers from Hebron (1994)
(3) Shana Tova (Happy New Year) (1983)
(4) Hands Up (1986)

Can you comment on your use of contemporary media in your work, like newspaper images – you take material from that day's press or television etc?

For me it's the fastest way of working and reacting – it's all about timing; timing is very important, as is working as fast as possible. Some of my pieces are almost ahead of time. I made a poster called Peace before the Saddat visit in 1977. This was the beginning of my political involvement as designer or visual communicator, which is a description that I prefer.

Israel has an annual poster competition to celebrate the foundation of the independent state of Israel in 1948. Each year there is a theme; the year of education, heroism etc. If I remember correctly, in 1977 the theme was something like nationalism and achievements in this area. I decided to do one thing. I put one word on a poster – 'Shalom', which means peace. It had a blue sky with the word Shalom placed within it. It was nominated for third prize. The three posters that were selected as prize winners were reviewed by a government committee.

Because it was announced that Saddat was going to visit, the committee said they wanted to award first prize to my work, but they insisted that I add Jerusalem to the poster. I wrote a letter to the prime minister explaining why peace – Shalom – is universal and should not be connected to a certain place such as Jerusalem. The committee with a majority of one vote accepted my proposal and this design led to me designing the logo for the Peace Now

movement, which was founded after the Saddat visit. Then I understood the power of visual communication for the first time – its effect on things such as politics and opinion.

You have an unusual approach to working with posters, and have produced almost two bodies of work; the posters that utilise the immediacy of news media imagery and then the more constructed work such as the Happy New Fear poster (p141). Can you comment on your approach to the second type of work?

Yes, in that work I try to do something different – using an almost advertising style of photography and text as a headline or strapline. I am playing with the language of advertising. I start my day by cutting out images from the newspapers and pasting them into books so that if I need an image I can find one quickly. I also have a number of agreements with press photographers who allow me to use their images in my posters. This collage approach is very important to my work. I imagine eventually having a massive archive of news images.

What is it about the format of the poster or working with posters that is so convincing?

Before I made posters I used to do a lot of record sleeves and I love working with the format of 21 x 21cm. It's the same thing with posters – the challenge to fill the blank page. Before the computer I used to work on a 1:1 scale when making a poster. The computer is like a pencil, another tool, but it is also a different way of working.

The audience for most of my work is very important to me – I make work for an Israeli audience, I don't think about magazines or publications or people abroad. Most of the images really only have meaning for that audience – they are Israeli clichés. If we look at the 30 Years of Occupation poster made in 1997 (pp42–43) the image is an icon from the '67 war and commemorates the 30th anniversary of Israel's occupation of the Palestinian territories. General Dayan, General Rabin and General Narkis are entering the walls of the old city of Jerusalem – if you are not Israeli you perhaps would not understand the significance of this.

There is a green line on the poster – what is a green line? A green line used to be drawn on Israeli maps to mark the border before the '67 war. The red crosses are perhaps more understandable: they operate in two ways. Each cross represents years, and three equals 30 years. They also cross out each person on the poster and they are all dead now – this was not really my intention and I got a good deal of criticism from people about it. The daughter of General Dayan, now a member of parliament, was upset and asked, 'how come he crossed out my father?' The black, red and green I used on that poster are the Palestinian colours. The symbolism of colour is important for me in my work.

You also use overprinting on the poster, onto what look like printers' make-ready sheets?
The work is printed on advertising pages, real estate adverts etc, and a memorial book for soldiers killed in the war. In the main

the choices were quite arbitrary. I wanted to show a noise, a build-up, a mess. It can also be read as showing how the occupation affects all spheres of life; cultural, social and business etc. I work in a local way – I used to use a statement on all my work, a kind of signature that said 'Produce of Israel' – I make images and work from the inside.

* This phrase, taken from packaging for mailing posters abroad, has been adopted by Tartakover as a motto for his political poster work.

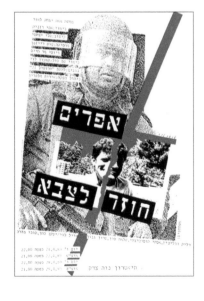

1 2 3 4 5

David Tartakover
(1) Life to Lebanon (2000)
(2) Childhood is not Child's Play (1998)
(3) Daddy, What are you Doing in the Occupied Territories? (1986)
(4) Back to the Army (1989)
(5) Bring the Settlers Home (2000)

WRITING ON
THE WALL

> The familiarity of the typographic form in part creates its very invisibility to the reader or viewer. To the non-trained eye, the finer details of the designer's choice of typeface and layout are often only noticed when the design does not function for whatever reason. However, posters, one might assume, are always noticed – due to their scale and location in the street – acting as a form of interruption in our visual landscapes. But how often does this really occur? As we navigate our daily routines we are surrounded by visual and typographic information all pressing for our attention and which, in the main, we regard as little more than wallpaper. This context is the starting point for the designer, who is required to employ strategies within the design of a poster that will enable communication with the intended audience and register within this sea of messages.

> The work in this chapter explores a particular focus within the field of poster design – that of typographic posters. These posters often employ dramatic hierarchies and expressive typographic layouts to dramatise a poster's message. The words on the poster might emphasise a particular aspect of its content, best expressed or 'fixed' through the rigidity of written language rather than the 'openness' or ambiguity of an image. Type can provide a strongly graphic sensibility when the shape of the letterforms are prioritised with the use of bold, flat colours. It may also be manipulated to give an impression of depth, create a sense of surface in relief or a diagrammatic look.

Stripped-Down Approaches

> The work of British design group 8vo for Factory Records in Manchester, UK (pp104–105) explores the possibilities of a purely typographic solution to a design problem. The poster in question – which appears in the Factory Records catalogue as Fac 56, a number system applied not only to records but posters and even the company's headquarters – was in fact produced to celebrate the seventh anniversary of the now infamous Haçienda Club. 8vo, recognised among designers for their attention to typographic and printing details, wanted to make a poster that responded to the environment in some way. The final solution was printed in luminescent inks that glow in the dark (p104). This poster – one of five produced for Haçienda birthdays between 1985 and 1991 – was commissioned by Factory co-founder Anthony Wilson. As Mark Holt of 8vo recollects "...each poster had an open brief and no commercial pressures" – just Wilson's encouragement to "make sure each one was better than the last."

> This stripped-down approach to typography, combined with adventurous printing techniques and no use of adornment of image or extraneous devices, is a recurring feature in the work of 8vo. The posters produced for the Flux Festival in Edinburgh, Scotland (pp106–107) again allowed the group to develop an approach over a period of time. Last-minute deadlines and late copy details led the designers to create a visual system that would allow copy to be flowed into posters for individual events during the festival. This systematic approach to typography is further developed through the use of a self-designed typeface called Interact, which is utilised in these 'information rich' posters.

Technical Construction

> Swiss designer Ralph Schraivogel produces posters for a range of clients including museums and cultural events such as the Zurich Film Podium. Schraivogel, winner of many international awards for his poster design, approaches each commission with the same purpose of exploring the technical limitations available to him. In the poster for a festival of films based on the plays of William Shakespeare (p108), Schraivogel produced a purely typographic solution, which is made even more challenging by his application of technical processes in the construction of the design. Using a peg board and plastic letters as a starting point, he then vacuum wrapped the type in foil, submerged the model underwater and took a photograph. The final image was printed in metallic inks to further emphasise the complex visual effects.

> A largely typographic solution is also employed for a season of Woody Allen films at the same festival. The layout and very visible grid system is based on a detail of the street map of Manhattan – also the title of the most famous of Allen's films. The client's insistence on the use of a picture of the director is subverted by the use of every image supplied to the designer for possible inclusion. The grid of a section of New York provides its own hierarchy for the typography employed.

Letters are Things

> The simple and direct posters produced by Marek Sobczyk for Polish theatre productions (pp110–111) were all produced by hand and printed in black and white. The hand-drawn typography and flat areas of black or white stencil increase the dramatic impact of this work – not only for the sophistication of its layout but because of a visual honesty remarkable in an age of technological layering and graphic effects.

> Italian designer Leonardo Sonnoli also explores the possibilities presented by the use of a limited colour palette. The posters for a series of lectures in the city of Pesaro, Italy (pp114–117) are examples of an extreme in typographic hierarchies – in one case employing a combination of giant full-page single letterforms set alongside information copy more akin to book copy in scale.

> Sonnoli often uses the form of the poster for personal research and typographic experimentation, developing an optically three-dimensional typeface under the heading of 'Wri-Things' (pp112–113) – a concept based on a quote from typographer Eric Gill asserting that "letters are things". These visual ideas are then often employed by him on subsequent commissioned posters.

> Sometimes Sonnoli employs both sides of a poster – for example, in his work produced for a series of graphic design lectures (pp114–117). Using typography as illustration or visual metaphor, Sonnoli unfolds the information contained within over each side of the poster – its significance becoming gradually apparent, as in the poster for the talk by Heike Grebin of design group grappa blotto (pp116–117). On one side of the poster, the name of the group is shown typographically as if carved into stone or metal – a reference to the design group's location in the former East Germany with its industrial and monumental heritage. On the reverse, the group's name is reduced to an initial 'g' and 'b' logotype – with a small grappa glass resting on it. Grappa, while part of the name of the group, is also a popular spirit drink in Italy.

Digital Design

> German design group grappa blotto employs a hard-edged aesthetic to their typographic posters for a number of Berlin based cultural clients. The choice of typographic treatments – distressed by digital manipulation (p118) or celebrating their digital creation (p119) for instance – is employed to create a visual metaphor. In the case of the Gut Zu Wissen poster, for a conference on the theme of a 'knowledge society', the group chose to highlight a theme of knowledge as empowerment rather than the contemporary currency of meaningless information.

> The digital is also explored in the work of Mason Wells (pp120–121) of British design practice North, in the poster for the launch of a book and exhibition by the International Society of Typographical Designers held in London. Using only type and a limited colour palette, the poster explores the visual language of both technology and typography to create a contemporary feel. This theme is also illustrated by British designer Ian Noble, of the design partnership Visual Research, in his poster for a conference concerning issues surrounding women and technology entitled Wired Women (p120) held on International Women's Day. Using only one colour, the designer has created a visual equivalence for the 'wired' aspect of the conference theme.

A Cut Above the Rest?

> The poster created by New York-based Austrian designer Stefan Sagmeister for the annual conference of the American Institute of Graphic Artists (AIGA) (pp122–123) is the most extreme form of typography. In this now notorious poster, the designer has cut the typographic information into his torso using a knife. Sagmeister's concept of visualising the ordeals of the design profession – "the fighting and the pain that seems to accompany most of our design projects" almost got the better of him when faced with the reality of cutting the type into his own body. In the end, a studio intern, Martin Woodtli, cut the information into the designer's body – a process that took eight painful hours before it was completed for a final photographic session. This dramatic approach to both typography and poster design could be seen as a backlash against the dominance of computer-driven design; as Sagmeister himself has said, it was an attempt to "touch somebody's heart with design".

1 2 3

DANIEL EATOCK/ERIN MULCAHY:
Walker Arts Centre Design Internship
707 x 1000mm US 1999

This two-sided poster (2, 3) represents every object produced by the designers during their first six months as interns at the Walker Arts Centre, US. Every page of each project undertaken is shown from front to back (detail 1).

The final poster was then overprinted with type in a second colour, in order to act as a publicity poster for the internship programme the following year. As Eatock states, "the resulting poster shows the scope of our production in literal terms, allowing a relatively simple idea to generate a complex form. A straightforward strategy of information display is countered by a personal commentary linked to each project."

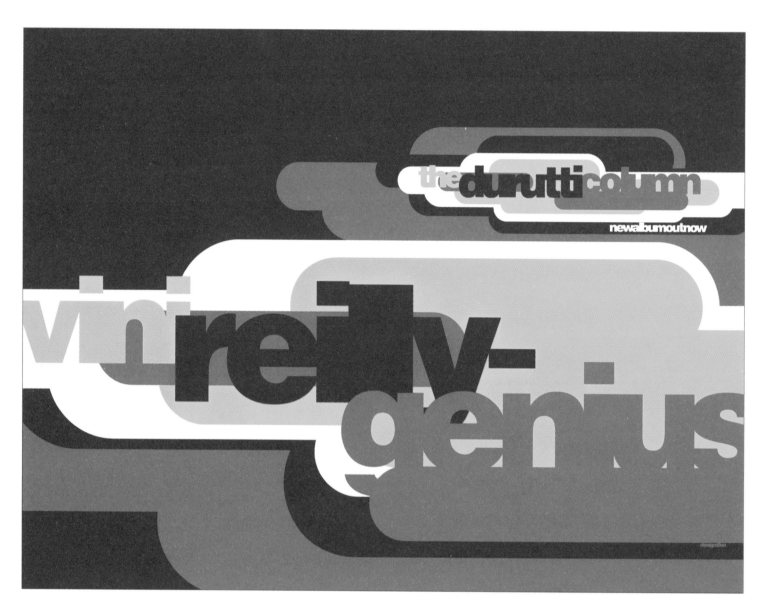

1 2
3

8vo:
Factory Records, Manchester
UK

Vini Reilly – Genius (1) was designed
by 8vo to promote the release of a
new album by Manchester group The
Durutti Column in 1990. The rather
arrogant, tongue-in-cheek title
is a reference to the group's guitarist
and songwriter Vini Reilly. This use of
direct, exaggerated language reflects
the local dialect of the city and its
claims to be the music and fashion
capital of the UK in the late 1980s.
The poster was silkscreen-printed in
three special colours, at Quad Crown
(30 x 40″/762 x 1016mm) and was
pasted on billboards around the city.

Haçienda Seven (2) measures
40 x 60″ (1016 x 1524mm)
and commemorates the seventh
anniversary of the Haçienda nightclub
in Manchester in 1989. The poster was
silkscreen-printed and included special
luminescent ink so that it would glow
in the dark (3). This dynamic visual
style perfectly reflected the drugs and
party culture of the club at the time,
and proved very popular with clubbers
leaving the venue in the early hours
of the morning.

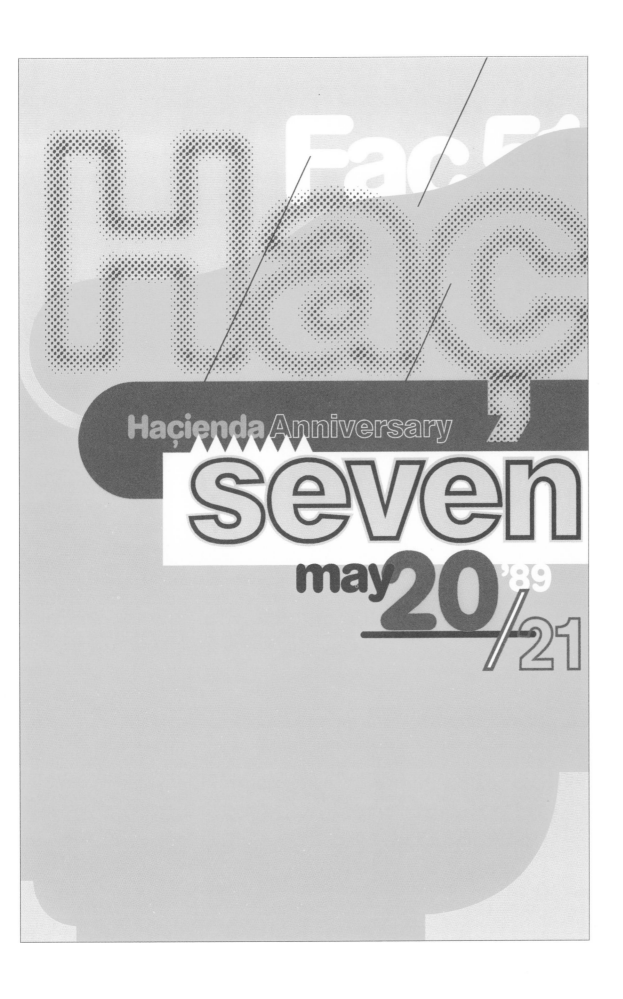

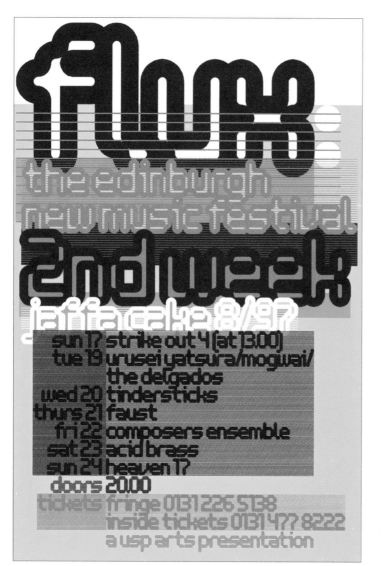

1 2 3
 4

8vo:
Flux Festival
UK

Between 1997 and 1999, 8vo were responsible for the design of publicity for the Flux music festival in Edinburgh, Scotland. As the details of forthcoming events were often finalised at the last minute and close to the deadline for poster production, the designers formulated a system in which copy could be flowed quickly into a flexible grid.

The design for the 1997 poster (1) also incorporated the production of a customised typeface, in a range of weights and styles, which could be mixed and scaled according to the amount of information required and the layout and format of the poster. In this case, the portrait poster measures 40 x 60" (1016 x 1524mm). The poster is litho-printed in a striking range of dynamic fluorescent colours.

The 1998 poster (2) adopts a similar format to the earlier work, though in this case the designers chose to work with a democratic approach to the hierarchy of information. All the bands listed have a similar typographic treatment in terms of style, weight and size, while the Flux festival heading is the only copy that is designed with a larger type size. Layering of type is given emphasis by the incorporation of horizontal coloured strips with white lettering reversed out.

Poster (3), again from 1997, is a 48 sheet billboard version of the smaller poster (1), again using the customised typeface and very bright contrasting colours. The 1999 poster (4) retains the use of fluorescent colours, though in this case the designers chose to use a standard typeface and a hierarchy of information through varying the size of lines of copy and band names.

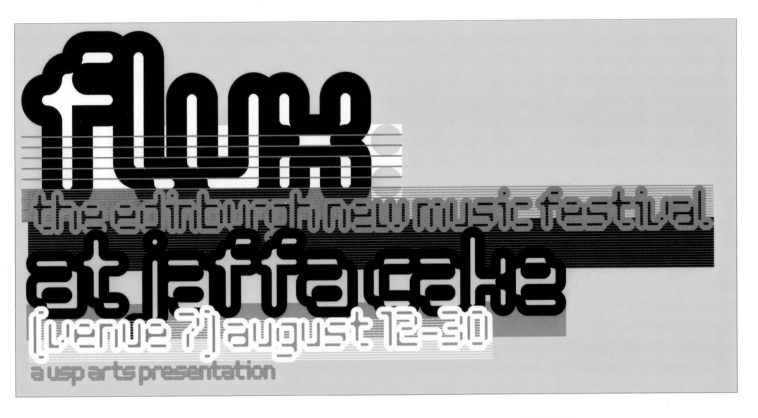

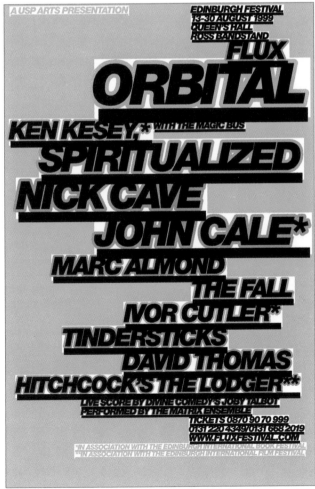

1 2 3 4
5

RALPH SCHRAIVOGEL:
Theatre posters
All 905 x 1280mm
Switzerland

Shakespeare's Cinema (3), produced for the Zurich Film Podium, Switzerland, in 1998, illustrates the designer's unusual approach to poster design: the creative approach utilises a range of studio photographic techniques and three-dimensional materials. Schraivogel constructed the typographic message using a peg board and plastic letters (1), then used this as a form to create a relief model that was subsequently submerged under water and photographed on a rostrum camera (2). The final poster was silkscreen printed in metallic silver and black.

Henry van de Velde (4), commissioned by the Zurich Museum of Design in 1995, again uses photographic techniques and litho film positives to create dramatic effects. The photograph of a chair by Henry van de Velde was copied using a manipulated line screen. The poster was then silkscreen printed in two colours, black and white, with the lines interfering with one another to produce a curved line moiré pattern. Despite its contemporary style – which might lead the viewer to assume it was designed by computer – the poster was in fact produced using a range of what could be termed more 'traditional' materials and non-digital techniques.

For the **Woody Allen** poster (5), again produced for the Zurich Film Podium in 1998, Schraivogel objected to the client's insistence on displaying a photograph and the name of the subject. As an ironic response, he incorporated all the pictures of Woody Allen the client had supplied, set against a grid from a street map of Manhattan – the district setting for many of Woody Allen's films. Making a reference to typographic hierarchy, Schraivogel states, "for once, I had no problem putting the address of the cinema big enough on the poster."

25 | OTWARCIE

AUTOR PROJEKTU OTWARCIE RYSZARD KAWALEC - BLUMENARt

ĐOSTOJEWSKИЙ

8.06 GODZ. 19.00

TEATR ACADEMIA UL. 11 LISTOPADA 22

WSPARCIE FINANSOWE GMINA WARSZAWA CENTRUM

"PROYECTO DOSTOYEWSKIJ"

ANTONIO SARRIO, DENIS SHIRKO, ZBYSZEK OLKIEWICZ

9.06 GODZ. 19.00

TEATR ACADEMIA UL. TARGOWA 80

"ŁAGODNA"

DAREK KUNOWSKI, SŁAWOJ JĘDRZEJEWSKI

1 2
3

MAREK SOBCZYK:
Otwarcie 22/Otwarcie 25
All 780 x 540mm Poland

Sobczyk designed these theatre posters for Ryszard Kawalec Blumenart, Poland. In each case, bold typographic messages were produced by hand, using paper stencils to create simple but dynamic silkscreen-printed posters. The poster for **Otwarcie 25** (1), in 2001, uses the weight of the black lines and reversed type to create a dynamic tension within the composition (detail 2).

For the **Otwarcie 22** poster (3), the designer's use of strong contrast and hard angles, both within the letterforms themselves and in the larger typographic composition, give a sense of drama to the poster. The heavy figures for '22' are balanced on either side of a bold diagonal. This sense of asymmetrical tension is further enhanced by the use of smaller texts that align with different angles found within the design of the larger characters.

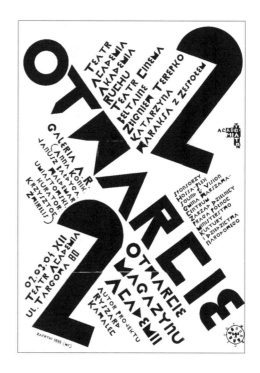

RLI

LEC – BlumenArt

RKH

SKH

SOWE GMINA WARSZAWA C

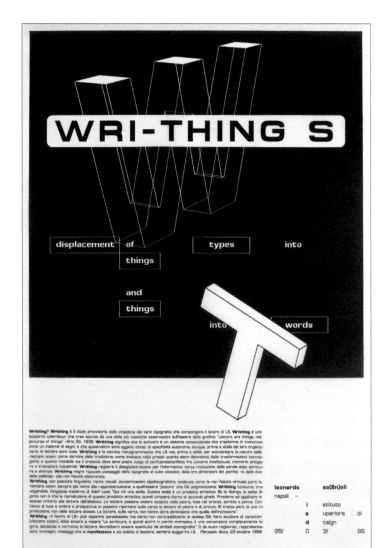

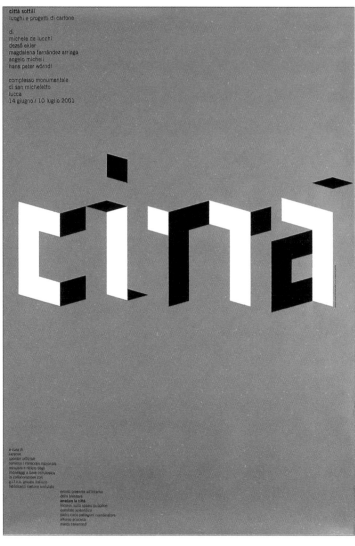

Wri-things periodic table by Dr. Soon Lin

1 2 3

LEONARDO SONNOLI:
Wri-Things alphabetic posters
Italy

Sonnoli uses the term 'Wri-Things' to define his research, as a direct reference to typographer Eric Gill's famous assertion that "letters are things". The concept was developed by Sonnoli into a series of posters and typographic experiments, such as the poster **Wri-Things** (1), produced to promote Sonnoli's lecture at Napoli Design Institute, Italy, in 1999. This includes a manifesto to explain the Wri-Things concept, and was offset printed in one colour on heavy translucent film.

A further development of the theme can be seen in the poster **Wri-Things Periodic Table by Dr Soon Li** (3), a self-authored piece of work promoting another lecture by Sonnoli at Venice Architectural University, Italy, in 2001. The poster was offset printed in two colours, and its title uses a humorous anagram of the designer's own name. Set in the style of the periodic table of base elements, the poster acts as a type specification sheet for Sonnoli's own diagrammatic, three-dimensional illusory typeface (used across the whole series of posters). The poster also cites the names of all the people Sonnoli credits as having inspired him in "considering letters as things".

The designer's interest in illusory and three-dimensional typefaces can be seen in much of his other work, such as the **Citta Sottili** (Thin Towns) poster (2). This is one of a pair of posters commissioned in 2001 by Lucense for an exhibition on cardboard design for public spaces, offset printed in two colours.

leonardo passarelli: conversazione su franco grignani, marzo 2001. a cura di leonardo sonnoli e pierpaolo vetta.

1 2

LEONARDO SONNOLI:
Franco Grignani
980 x 680mm Italy 2000

A double-sided poster, produced by Leonardo Sonnoli and Pierpaolo Vetta for a lecture on Franco Grignani, an Italian graphic designer. The poster was offset printed in matt black using a matt varnish on both sides. It attempts, in Sonnoli's words, "not to imitate the Grignani style, but to interpret typographically his approach to design. A double-face typographic optical illusion." Again displaying the designer's fascination with the illusion of three-dimensionality, both sides of the poster are connected by the same grid, allowing the two faces to be hung side-by-side to produce a longer poster.

Sonnoli employs an extreme form of typographic hierarchy in many of his poster designs. Both sides of this poster carry contextual information in one line of small type along the top edge, stating "Leonardo Passarelli: conversazione su Franco Grignani, Marzo 2001. A cura di Leonardo Sonnoli e Pierpaolo Vetta." (Leonardo Passarelli: Lecture on Franco Grignani, March 2001. Presented by Leonardo Sonnoli and Pierpaolo Vetta.)

1 2

LEONARDO SONNOLI:
grappa blotto lecture
980 x 680mm Italy 2001

A double-sided poster, produced by Leonardo Sonnoli and Pierpaolo Vetta for a lecture by Heike Grebin of the German design group grappa blotto (pp118–119). Once again, the designers chose to interpret the approach of the featured designers, rather than imitate their design work.

Sonnoli describes the poster as being based on a logotype cut into a heavy steel plate, indicating the strength of grappa's design work and their origins in the former eastern bloc. The characters spelling out the name grappa blotto (2) are designed to mirror one another along the central horizontal axis, and the reverse of the poster (1) shows "a constructive logotype with 'g' and 'b' with a typical little grappa glass."

The poster was offset litho-printed in three colours with a matt varnish, and Sonnoli chose to use a metallic silver ink to emphasise the steel plate effect. Typographic hierarchy is again quite extreme, the central type and image being dominant over the additional information set in two lines of small type traversing the cross device on both sides of the poster.

1 2 3 4

GRAPPA BLOTTO:
Cultural event posters
Germany

Bohemia and Dictatorship in the GDR
(1) was designed by grappa blotto as
an exhibition poster for the Deutsches
Historisches Museum in Berlin,
Germany. The exhibition was about
autonomous artist groups in the
German Democratic Republic between
1970 and 1989. The poster was
screenprinted in two colours, is A1 in
size (594 x 841mm), and uses rough
typographic characters, distressed by
digital manipulation, set against a
series of lines of crosses, in the form of
barriers or borders.

Ship from the Desert (2) was an A2
(420 x 594mm) screenprinted poster
for a 1998 exhibition in Potsdam,
Berlin, of artists from Santa Fe in New

Mexico, US. The image is a real photo
of the desert in New Mexico that was
taken by Saskia Wendland, the sister of
Tilman Wendland of grappa blotto who
designed the poster. Coincidentally, she
had been in New Mexico prior to the
exhibition. The image is printed with
two line-halftones that have been
slightly rotated, and the resulting moiré
pattern becomes a mirage over the
desert floor.

Religion and Gender (3) promotes a
congress held by the Heinrich Böll
Foundation in Berlin, 2001, concerning
the changing role of women in religion
in Eastern Europe. The poster is A2 in
size and litho-printed in three Pantone
inks – the poster uses the standard

colour palette of the client's publicity,
developed by grappa blotto in their
identity design for the Foundation.

Good to Know (4) is a poster for a
congress hosted by the Heinrich Böll
Foundation in Berlin, and is A2 in size.
The congress was a forum for
discussion about the idea of the
'knowledge society' – an attempt to
redefine the existing discourse about
the 'information society' – the idea
being that 'knowledge' suggests an
empowering, democratic force, while
'information' is little more than
intellectual currency.

1 2 3

MASON WELLS:
STD Retrospective
420 x 594mm UK 2001
IAN NOBLE:
Wired Women
420 x 594mm UK 1998

Wired Women (1), designed by Ian Noble, was created for a conference of the same name concerning issues surrounding women and technology. It was held on International Women's Day in 1998. Working with a limited budget and using only one colour, the designer has been able to create a visual equivalent for the 'wired' aspect of the conference theme.

STD Retrospective (2) was produced by Mason Wells for the launch of a book in 2001 collecting together 30 years of design writing in the journal Typographic, produced by the International Society of Typographic Designers. The designer employs a visual language of digital technology (detail 3) to make the connection to changes in the profession of type design and typography.

The poster employs a limited colour palette to great effect – the use of a black background creating a cool, sophisticated feel.

1 2

STEFAN SAGMEISTER:
AIGA Detroit poster
US 1999

Sagmeister's poster for the American Institute of Graphic Arts conference 1999 (2) was devised as a darkly humorous and self-referential piece of art made by cutting directly into the designer's own body. The concept was devised in order to "visualise the pain that seems to accompany most of our design projects."

Preliminary sketches for the work (see interview p126) show Sagmeister developing the concept and detailing each piece of text that would need to be included for the poster.

Once a typographic hierarchy had been established, which would enable the positioning of each piece of text according to its function and relevance, Sagmeister and his design intern, Martin Woodtli, cut the words directly into his body with a scalpel (1). As Sagmeister admits in his notes on the work, "Yes, it did hurt real bad." Once all the text had been cut in this way, Sagmeister's torso was photographed by Tom Schierlitz to produce the final image for the poster.

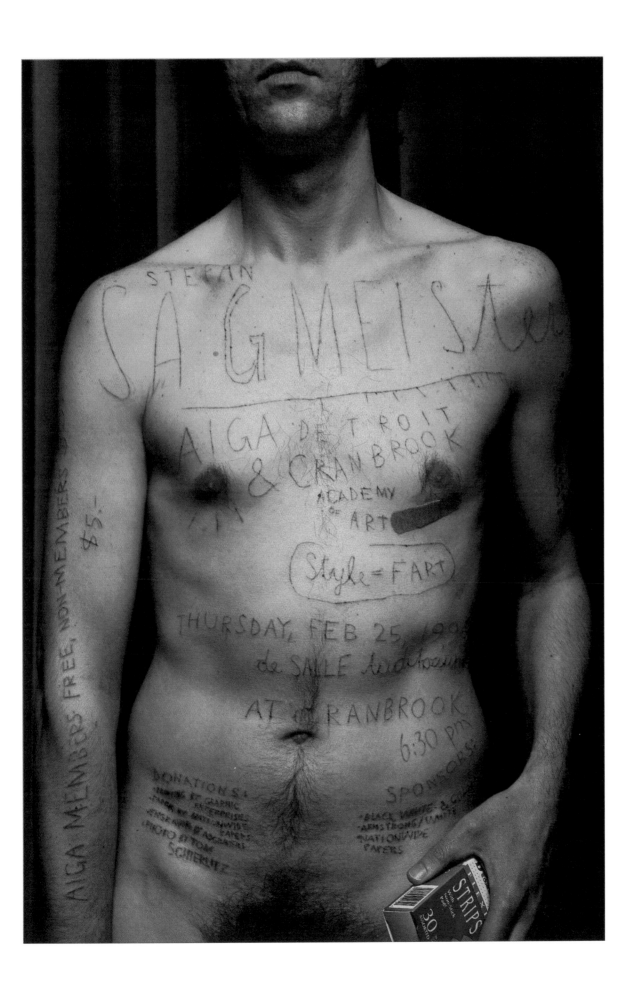

WHO IS THE ASSHOLE WHO DESIGNED THIS POSTER?*

Stefan Sagmeister (b. 1962) is well known as a graphic designer, working with a range of prominent clients within the commercial and cultural arenas, such as the American Institute of Graphic Arts, and famous rock music clients such as the Rolling Stones, David Byrne and Lou Reed. His design for the now infamous poster for the AIGA event in Detroit (pp122–123) employed the strategy of cutting type into his own torso. This method was also used by Sagmeister for his section in the book Whereishere?, designed by P Scott and Laurie Makela in 2000.

What were you thinking of when you carved the AIGA event details into your own body to produce a poster?
I had seen a whole lot of lecture posters, almost its own category within our little field. Most of them say: design is a colourful profession, design is an idea-based profession, design is a stylistic profession, many make reference to some sort of city cliché (where the lecture takes place). I did not want to follow that path. I tried to visualise the pain that seems to accompany at least some of our design projects, even the ones I wind up liking when completed. The whole thing is informed by fine art (performance from the 1960s and 1970s) as well as newspaper coverage (there was quite some type-cutting going on at Anwar Sadat's funeral as well as Marilyn Manson's concerts). In actuality, it hurt really bad, the cutting took much longer than anticipated (eight hours) and I have no desire to revisit that technique again.

Rick Poynor has written that your use of a photograph of your own testicles in Whereishere? and the cutting of type into your own body is an ironic comment on our collective self-obsession – a left-over from the 'Me Decade'. Was your intention in line with this?
It seemed to me that when talking to a design audience, a personal view might be more powerful, simply because we've seen and probably used all those commonplace design clichés before. So when Scott and Makela asked me to design a spread containing personal work for the Whereishere? book (and later on the lecture poster), the audience for both being other designers, I felt it justified that this work should be about me, me, me – after all, it should be personal.

Your AIGA poster for the 1997 annual conference in New Orleans ignores the established 'rules' of how a poster should operate, loading the reverse side with a dense amount of information in order but without any particular hierarchy. Given that the poster was to advertise an event for graphic designers, were you making a comment about design?

The AIGA just sent over a ridiculous amount of copy. We first tried the information architecture thing – colour coding and rules and all, then threw everything out and wrote it any which way. The left-over spaces were filled with our own stories, pictures etc.

The image shows a large headless chicken running around a field with a typeface made of chicken claws, advertising a conference with the theme of 'The design of culture, the culture of design'. Were you having a pop at the vast rump of graphic design output or were you exploring other ways of self-expression?

Both. It became clear that they were going to have 70 speakers in six venues in two and a half days, so the resulting chaos at the conference was predictable. When we do these freebie jobs, we try to do something that brings us further too.

Like corporate and mainstream visual communication, a lot of your work operates on a simple level, but it avoids the anonymity this can bring. How do you manage this?

I used to think that it's about problem solving and that the designer should stay out of it as much as possible. But having seen how much bland, forgettable work this kind of thinking produced, I now think that it is very important for the designer to bring his/her own point of view into the proceedings. Much like a conversation with a friend: you don't just want a story retold as he/she heard it, but also his/her personal opinion about it. Designers are like actors: the script (content) remains the same but a character takes on a very different angle if played by Dustin Hoffman or Bruce Willis.

Was your approach influenced by working with Tibor Kalman, who like you was able to operate both within the mainstream of graphic design and at its margins?

Yes. Tibor was a big influence. Yes, ideally, I love to operate in both. My hero in film is Soderbergh, who can direct a beautiful tiny movie but can also deliver a huge blockbuster. I think there are interesting aspects in both worlds. Tibor's line was that he has a desire to have real cultural impact, which is much more likely achieved in the mainstream. I think it's such a pity that so many of the huge identity/packaging/design projects are developed by the marketing/branding idiots and many fantastically talented designers design posters for a tiny theatre.

Why are you drawn to hand-rendered type in your work on posters and record sleeves?

I am not obsessed with typefaces and find the selection of just the right one a rather tedious exercise. Using my handwriting eliminates that process, personalises the piece and can be interpreted as an anti-computer statement all in one easy move.

1 2 3

Stefan Sagmeister
(1) Page from the book Whereishere (1999)
(2) AIGA Conference 1997 (front)
(3) AIGA Conference 1997 (reverse)

Are you attempting to avoid a 'style' in your own work – if that is at all possible – or as in your statement style=fart are you making an ironic comment on design's inability to escape stylistic considerations?
I have also changed my mind about this: we used to have the style=fart sign in the studio, but it was brought down by water damage and since then has not been replaced.

The Fresh Dialogue poster goes beyond stylistic nuance to work in an original way. It functions formally as a poster, using bold and succinct type and image, but it is organic and fleshy, removed from more polished design.
Yes. That's a sweet interpretation of my style=fart line.

You are an Austrian working in the US – do you feel a connection to any particular European heritage in your work?
Well, there is the entire poster history, and the fact that posters still make sense in European cities and their pedestrian zones. Posters in the States are pretty much dead, because outside of New York nobody walks and therefore they are not much seen by anybody. Sometimes it seems the only reason they are alive is because designers like them. I grew up in Austria when Brus, Muehl and Wiener were really big in Vienna (Actionism). Furthermore – possibly as a left-over from the Secession in 1900 and the Wiener Werkstaette, all the applied arts are on the same status or level as the fine arts.

The University of Applied Arts in Vienna is actually considered a more sophisticated institution than the University for Fine Arts. Design in America is much more about selling: it has to do that first and foremost, and if it could be, as a bonus, also 'good design', well then, the client does not mind. I used to have a client in Austria who said that first and foremost it had to be good, he was not interested in commissioning anything less than exciting. Life=short. The selling part was the bonus.

** Comment by a design critic in a review of Sagmeister's AIGA 1999 poster.*

1

Stefan Sagmeister
(1) Preliminary notes and sketches for
 AIGA 1999 poster (p123)

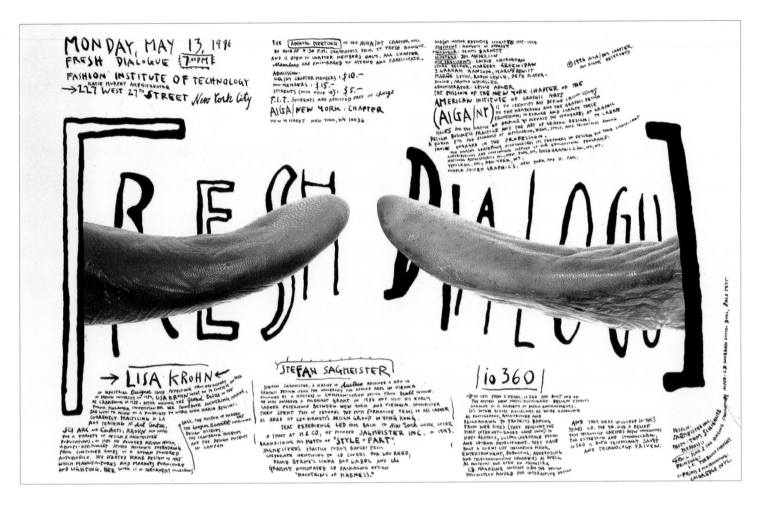

1

STEFAN SAGMEISTER:
Fresh Dialogue AIGA poster
990 x 610mm US 1996

As designer Stefan Sagmeister himself says, "two tongues opposing each other are an obvious symbol for a design lecture called Fresh Dialogues." What is unusual is the manner in which he has gone about constructing the poster, which advertises his own involvement in a lecture given at the Fashion Institute of Technology in New York for the American Institute of Graphic Arts. After conceiving how the poster should look, Sagmeister and the designers in

his studio all proved to have inadequate tongue lengths for the subsequent photo shoot.

Photographer Tom Schierlitz bought two fresh cow tongues from the nearby meat market and shot them with a 4 x 5″ camera. As Sagmeister says "...somehow they came out rather phallic. We did not mind but some AIGA members did." The approach and the use of hand-rendered typography

are recurring strategies in Sagmeister's attempts to produce graphic design that will "touch somebody's heart".

> Fundamental to nearly all graphic design is the use of words and images and their relationship to each other. Within the field of poster design this is especially relevant – as Richard Hollis has said, the graphic design of a poster "...exemplifies its essential elements – alphabet and image – and its means of reproduction."

Reinforce and Contradict

> The designer is involved in making key decisions about the kind of image and typography employed within a poster. Further skilled choice is necessary in the laying out of the elements to reinforce the content. Words can be used to reinforce the message within the poster, highlighting a particular meaning of an accompanying image. This role – described by French literary theorist Roland Barthes as "anchorage" – fixes a message through a caption such as a headline. In other cases, the words might offer a counterpoint to an image, surprising the reader and opening up unusual or contradictory meanings.

Disrupting Visual Codes

> The posters in this chapter designed by David Tartakover (pp140–141) could be described as following this contradictory route. Images of a gun and a petrol bomb are juxtaposed with texts that on first reading appear to be celebrating a Happy New Year – though on closer inspection the text ironically reads 'Happy New Fear'. The context for these posters is located within the current troubles within Israel and the occupied territories of Palestine. The combination of a surprising text and image help to grab the viewer's attention, while at the same time offering a level of complex information that draws the reader in and encourages a deeper reflection on the work. These posters exploit our familiarity with the visual language of advertising; the unexpected objects of destruction and terror being beautifully photographed in a studio and then treated with a typographic message that only reveals its true meaning on closer inspection.

> A similar approach was adopted by the designer for the poster United Colors of Netanyahu (p140). This poster uses a press photograph of Israel's then president surrounded by security forces. Tartakover distorts the picture's original meaning with an accompanying strap-line playing on the visual typographic style of clothes label Benetton's infamous advertising campaign by Olivero Toscani. This method of disruption of an accepted visual code can be termed 'detournement', after the theories developed by Guy Debord and the Situationist movement of the 1960s.

> Tartakover takes the notion of type and image working together to an extreme in the poster Freehand Design (p141) in which he employs a press photograph of a kidnapped activist. The victim has written the details of his imprisonment onto the palm of his hand and has held it up to photographers as he is being transported by car. Tartakover says that for him, as a poster designer, this is the ultimate poster and one he aspires to recreate for its simplicity and directness. His role as a designer in this instance has just been in the careful selection and cropping of an image – and this in some part is only possible because of the long-standing relationship Tartakover has with local news agencies who allow him access to their work.

Irony and the Vernacular

> The ironic, sometimes comical, use of words to imply a different (or surprising) context for an image is a common device in poster design. Often this is employed with material of a difficult nature or that relates a serious message.

> American designer Art Chantry's work often makes ironic use of stock illustration from old trade and mechanical parts catalogues, or from public announcements of the 1950s and 1960s. This appropriation of 'low art' or 'undesigned' forms has been referred to within graphic design as the use of the vernacular. The poster takes a familiar 'official' tone when viewed from a distance, but this meaning is overturned when the text is read close at hand. Chantry's poster Penis Cop (pp132–133) was designed for the Washington State Department of Health and Social Services in the US to promote safe sex and the use of condoms among gay men. The poster takes a mock-authoritative image of an official, whose 'voice' in the accompanying text gives a surprising message to the reader. Chantry refers to this approach as the use of "satirical and pompous authoritative information to create an otherwise false sense of community."

Word as Image

> Occasionally, the text on a poster forms the basis of the image itself, as in the case of Teresa Sdralevich's poster The Boomerang (p135), which utilises bold lines and typographic marks to imply a fraction of the swastika symbol. Sdralevich often limits her working process to simple typographic means, communicating a very strong message through the astute use of certain marks. In the 1933% poster (p137), for instance, the use of particular colours and typeface give enough clues to the reader about the subject,

and further imagery is deemed unnecessary. The words are set in the typeface Fraktur, which was employed by the German National Socialist Party prior to the Second World War. This choice of colour and typeface is enough to set the context for the poster's message about the rise of the new right Vlaams Blok in Belgium, who in the year 2000 polled some 33% of the vote in the country's elections. The poster's intended audience – in particular politically motivated individuals in northern Europe – would recognise the type style's significance instantly.

> In other posters designed by Sdralevich dealing with similar issues (p136), she utilises both hand-drawn imagery and typography, which work together to reinforce the simplicity and directness of the message. This technique refers back to early methods of poster production. While crude in production techniques, the posters achieve a sophisticated level of communication in the interplay between the enigmatic illustrations and the statements used – for example in the poster depicting a headless torso (p136), which is juxtaposed with the text 'history suffers from amnesia'.

> Philippe Apeloig's poster The Roth Explosion, designed for a French book festival in Aix-en-Provence (pp142–143) takes the visual reference of typography one step further, by composing an image – a portrait of the author, Philip Roth – through the careful use of typography. Basing the design on an original photograph, Apeloig is able to create a typo/portrait by varying the sizes, weights and lines of type, each using the title of a book by Roth. From a distance, the poster acts like a halftone image and the face of the author can be clearly recognised; in close detail, the poster reveals another level of information – the words integral to both the author and his depiction on the poster.

> This notion of text as image, or intertwined with image, is explored in a more formal way by Vince Frost in a poster for the London International Festival of Theatre in July 2001 (pp138–139). In this case, the disorientation created by the dramatic, unusually cropped, photograph is further enhanced through careful typographic composition. Frost uses dynamic angles set against the grid created by the image in the photograph, which are at odds with the square edges of the poster. The typeface employed is chosen to echo the shapes and materials of the crane photographed from below, while the colour palette mirrors that of both the crane and warning signs on construction sites.

> In the self-authored poster by French designer Alain le Quernec entitled Liberty/Mandela (p145) the subjects of Apartheid in South Africa and the former prisoner Nelson Mandela are explored. Le Quernec treats the typography as the image for the poster; the type is drawn by hand, visually reinforcing the message in an insistent and demanding manner, but the message contained on the poster is subtle, engaging the reader in a game of word play. The statement 'La Liberté de Mandela' (The Freedom of Mandela) can also be read 'La Liberté demande la' (Freedom Needs This).

Visual Metaphors

> Berlin-based designer Sandy K. uses subtle pictorial references in his poster Engagement and Graphic Design (pp146–147). The poster, promoting an exhibition and series of events intended to bring together political activists and designers, makes reference to earlier work of, among others, John Heartfield, Roman Cieslewicz and the Grapus collective. The central image of a hand is drawn from an original Heartfield German Communist party poster of 1928, while the eye and the brush are a visual homage to the quote by Cieslewicz claiming that designers have a responsibility to make images that "clean the eye".

> Sandy K. states that central to his approach to poster design is his concern with "image creation" and the use of visual metaphor. This can be seen in the poster design for the video activist group Ak Kraak auf Reisen (p149). This employs an unusual format in that it is intended to be displayed in multiple – in Sandy K.'s words, like "wallpaper" – and those responsible for the display of the work are allowed to choose which way to orientate the poster, which depicts the television ablaze or taking off like a rocket. In the poster created for Hybrid Video Tracks (p148), the television is portrayed as a frame or window on the world, also allowing the spectator to become part of the poster by making additions to the image if they choose.

1 2

ART CHANTRY:
Penis Cop
580 x 810mm US 1996

Chantry designed this AIDS awareness poster as a 'pro bono' project, which was commissioned by the Washington State Department of Health and Social Services, US. Aimed at gay men, the poster employs what Chantry describes as "satirical and pompous authoritative information to create an otherwise false sense of community."

Chantry's design work has become synonymous with the use of vernacular pictorial references that are drawn from technical and instruction manuals and cheap illustrations from the 1950s and 1960s. This poster, offset litho-printed in three colours, takes an image of a policeman from a public information poster and reworks the message into a humorous instruction on the use of condoms to prevent the spread of sexual disease.

The strap-line, "I take one everywhere I take my penis", implies a direct voice of authority, and is specifically designed to relay a very serious message in an amusing and ironic manner. This use of visual and textual language is targeted to a specific audience, in particular young people who may feel disaffected by official government warnings on the subject. The poster was hung in public restrooms, saunas and corporate offices – in Chantry's words, "those locations where sexual activity might take place."

seline
risco
l Whip
dpaper
d Lotion
tor Oil
n Lotion
y Oil
tter

ndoms
otect
ainst:

AIDS
erpes
philis
orrhea
al Warts
mydia

VOID
the
CREEPS!

take one

the boomerang

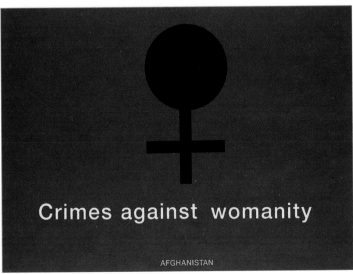

Crimes against womanity

AFGHANISTAN

1	2
3	4

TERESA SDRALEVICH:
The Boomerang
760 x 980mm Belgium 1996-2000
Crimes Against Womanity
1000 x 707mm Belgium 2000

(1) Work in progress for a political poster (2) entitled **The Boomerang**. The poster utilises a heavily cropped Nazi swastika symbol, which is still instantly recognisable due to the colours and the right-angled black line set against a red circle. The ironic title at the base of the poster indicates the designer's concern with the return of right wing ideology in Europe.

For her initial poster in 1996, Sdralevich drew the curve using her kitchen table as a template, and used some old Letraset for the type and black paper for the right angle. She later reprinted the poster in 2000, but retained some of the simplicity of approach by reworking the type and cutting the film with a huge handmade pair of compasses.

Notes and sketches (3) for a poster on the subject of the abuse of women's rights in Afghanistan show a concern with simplicity and the transmission of a direct, understandable message. The designer worked through a range of possible rough ideas, eventually working up to a colour layout on the computer, which she then silkscreen printed full size, 70 x 100cm.

She decided eventually to return to an earlier approach, which is again very simple and direct. Sdralevich felt that the use of photographic images detracted from the central message she wanted to put across, which she thought was focused within the text.

The final poster (4) utilises another widely recognised symbol, set against a plain, dark-coloured background. The bold statement 'Crimes Against Womanity' runs underneath and a smaller caption giving a context for the poster, 'Afghanistan' sits below that.

1 2 3 4

TERESA SDRALEVICH:

Anti Fascist posters

420 x 594mm Belgium

Sdralevich once again highlighted the political theme of **The Boomerang** within this series of posters, developed at the same time, which employ simple line drawings and phrases to deliver powerfully direct messages. The first three posters (1, 2, 3) use illustrations that add a striking or humorous message to reinforce the text.

The set of three posters were first worked up using photocopies and Letraset text, in a similar fashion to **The Boomerang**, then reworked as silkscreen prints. The illustration in poster (1) gives a darkly humorous interpretation to the text 'keep an eye on the past' by placing an eye on the back of the man's head.

In poster (2) a rhinoceros, hidden in shadow, gives a threatening emphasis to the typographic message, 'Vigilance – Fascism'. Sdralevich thought that the rhino was a good image for brutal totalitarianism, and Ionesco's play Rhinoceros was also an influence for her.

In poster (3), the text in French reads 'L'Histoire souffre d'amnésie" (History Suffers from Amnesia), a message that is again strikingly reinforced by the illustration of a running, naked, decapitated woman. The character has lost her historical consciousness, while also making a reference to violence. The designer states that 'Historia' is usually a female character."

Poster (4), entitled **1933%**, was produced as a silkscreen print in 2000. Sdralevich had been working with the AFF, an anti Fascist group in Antwerp, Belgium, before the October elections that year. The Vlaams Blok, a right wing party, were very successful in the elections, gaining 33 per cent of the votes cast. Sdralevich used the figure to draw a parallel with 1933, when Hitler came to power in Germany.

The designer stated that the type "just imposed itself" – the use of the Fraktur typeface reinforces the message in a very powerful way, while the choice of colours (orange for the Vlaams Blok and brown for National Socialism) again drew on direct historic links.

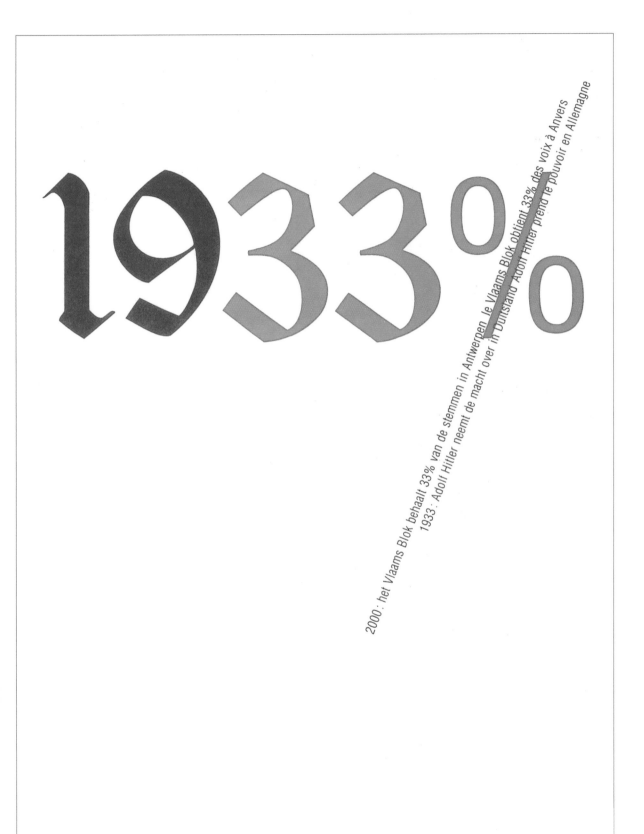

2000: het Vlaams Blok behaalt 33% van de stemmen in Antwerpen, le Vlaams Blok obtient 33% des voix à Anvers
1933: Adolf Hitler neemt de macht over in Duitsland, Adolf Hitler prend le pouvoir en Allemagne

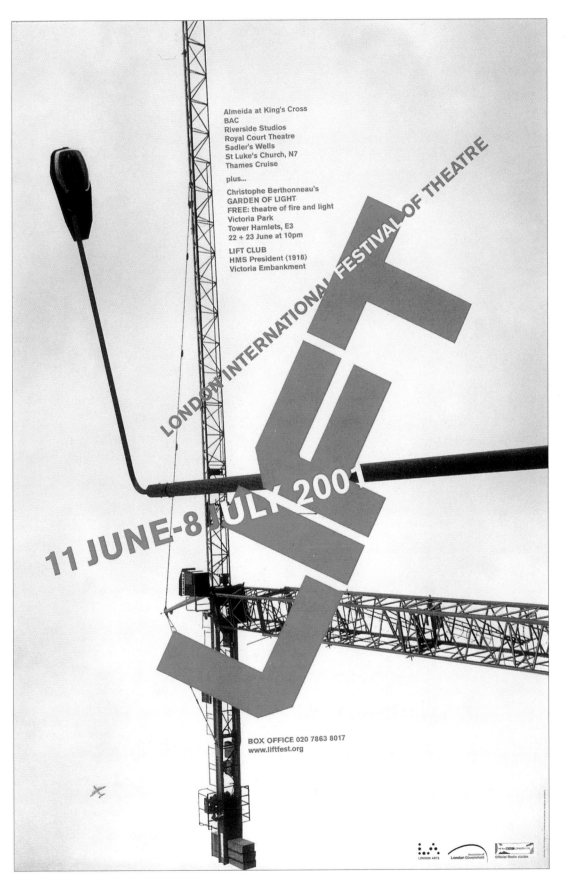

1 2

VINCE FROST:
LIFT promotion poster
1016 x 1524mm UK 2001

This poster was designed by Vince
Frost as part of a range of publicity
materials to promote the London
International Festival of Theatre, UK.
The large scale poster was litho-
printed, and uses a dynamic
photograph of a construction crane,
taken from ground level, creating a
strongly angular and colourful grid
for the typography.

The composition of the image, which
plays on a tense opposition between
the respective angles of the crane and
a street lamp, allows the designer to
build upon a feeling of dizziness or
circular movement on the part of the
viewer. All the publicity materials
were based on the use of this one
central photograph, with alternative
typographic treatments dependent
on each format.

The use of strong colours and bold,
interlaced typography creates a
vertiginous feeling of tension between
text and image. Some of the text (for
instance the smaller details of the
event) follows the lines of the crane in
the photograph, while the main title
and dates (detail 1) cut across the
centre of the poster, giving a sense of
movement and further reinforcing the
feeling of disorientation. The central
title, 'LIFT', uses a heavy geometric
typeface, which also gives a sense
of construction through its angular,
regular form.

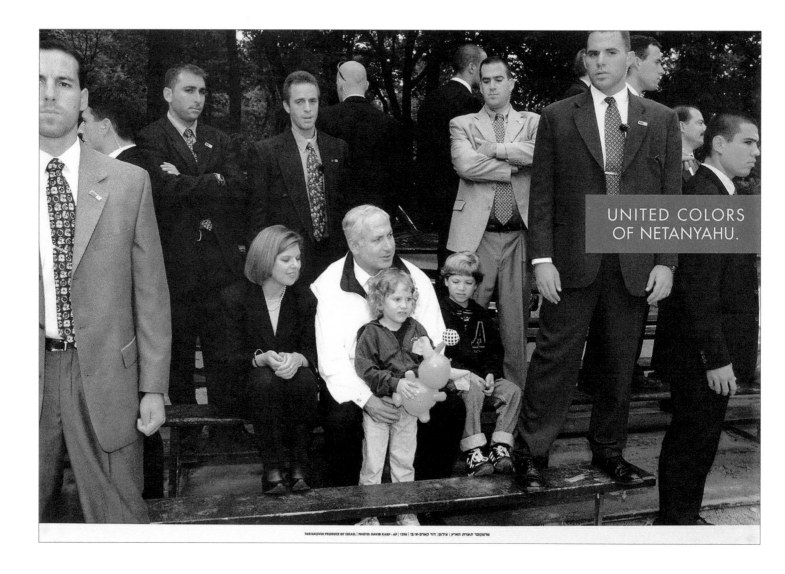

UNITED COLORS OF NETANYAHU.

1 2 3
 4

DAVID TARTAKOVER:
Palestine posters
Israel

United Colors of Netanyahu (1), designed in 2000, shows a photograph of former Israeli Prime Minister Benjamin Netanyahu on a visit to New York, with his family, surrounded by bodyguards. Tartakover added the green strip and ironic headline, using the same typeface and colours as the Benetton clothing company's own marketing campaign. He states that he dislikes the "manipulations of both" Benetton and Netanyahu and their attempts to "bend reality" to present a false public image.

Tartakover goes on to state that the message promoted within this self-produced poster is "one of 'Consumer Beware', whether consumer by choice (of merchandise) or by default (of an elected regime of the hawkish right)."

The poster entitled **Freehand Design (Motto of my Work)** (2) from 1986 shows an image of Mordechai Vaanunu, an activist kidnapped and arrested by Mossad, the Israeli secret service. While being driven to court, Vaanunu pressed his hand to the window of the car. On the palm of his hand he had written the details of where and when he had been kidnapped, information that was prohibited for publication in Israel.

This direct action communicated his plight directly to the media. Tartakover simply re-presents the image in poster format, giving a powerful message which symbolises a metaphor for his own work.

The **Shana Tova** (Happy New Year) poster (3) was produced in September 1987 as a greeting poster for the Jewish New Year (Rosh Hashanah), and features an offset printed photograph of a Coke bottle in the form of a petrol bomb, filled with olive oil. December 1987 marked the outbreak of the Intifada – the Palestinian uprising against the Israeli occupation. A similar theme was explored by the designer in the **Happy New Fear** poster from 1995 (4). The poster features a photograph of a gun, symbolising violence within Israeli society and the occupied territories.

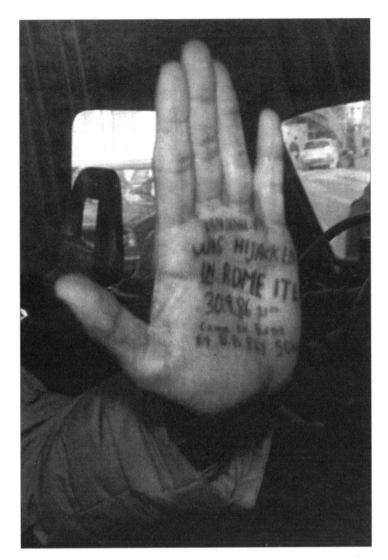

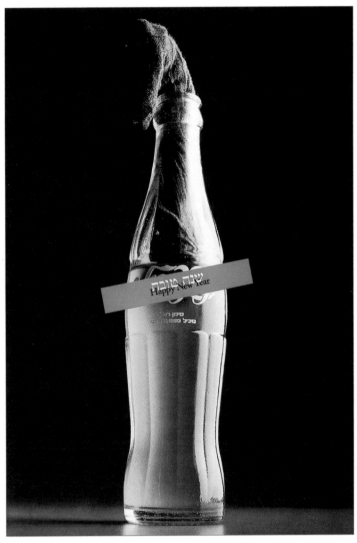

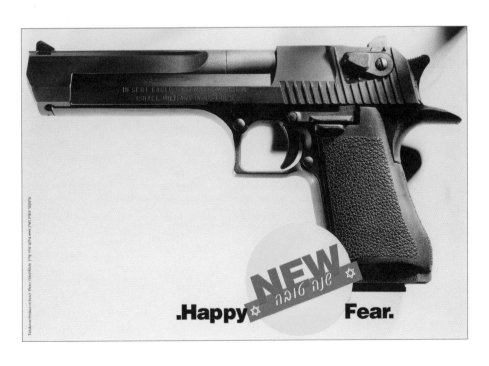

Photo: © Nancy Crampton

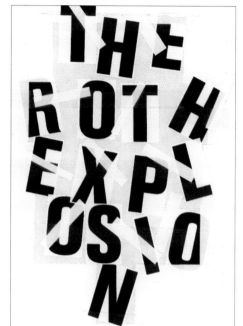

1 2 3 4

PHILIPPE APELOIG:

The Roth Explosion

1150 x 1750mm France 1999

Apeloig designed this poster for a French book festival in Aix-en-Provence, featuring the literature of author Philip Roth. The poster is composed using each of the titles of Roth's books. Apeloig states that "it gives the feeling of an explosion of millions of letters representing his face. In using this technique, I wanted to communicate his obsessive work."

He took his initial approach from a photograph of the author by Nancy Crampton (1), which he then attempted to combine with early typographic treatments (2). He suggests that his resulting technique, which involves

placing the letters one by one across the photograph, could be described as "drawing with typography".

Apeloig elaborates, "first of all, I want to say that graphic design is a form of art. However, the basic objective of the graphic designer is communication. An impression of spontaneity should remain, even if it takes meticulous control. Most of the time I start with the text – the typeface, and then move on to the images. I use film editing techniques, 'cutting' my ideas into pieces which I then reassemble in a different order. I work on them until the composition freezes and seems

strong enough. The poster is a popular image which belongs to the urban environment. People pay attention to a poster for less than a minute. So, the visual impact on the public must be strong, and the concept must be predominant."

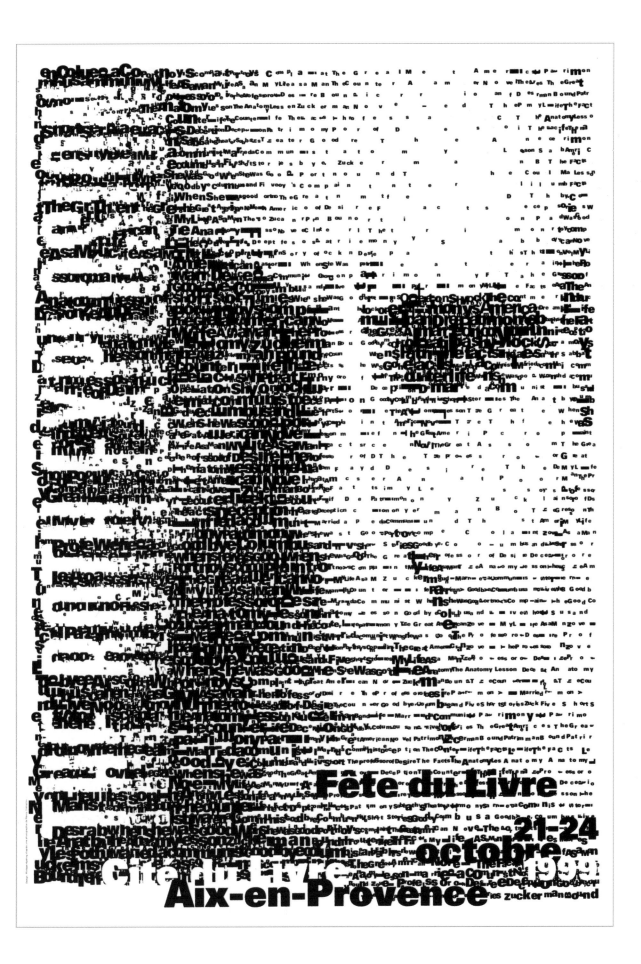

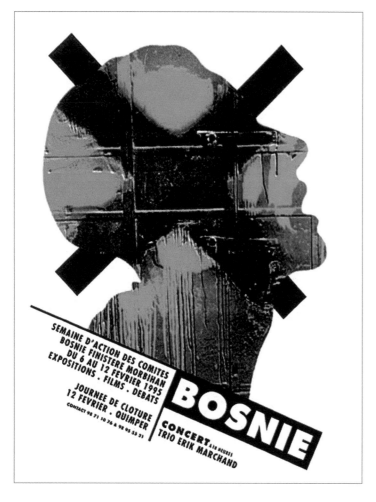

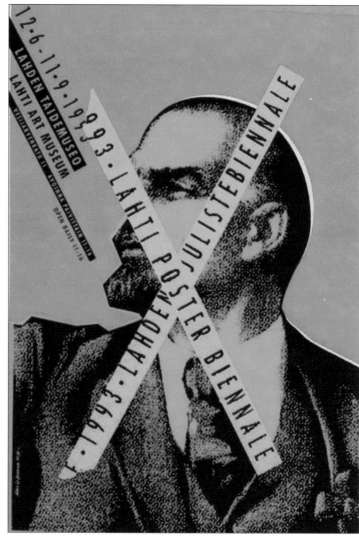

1 2 3
 4

ALAIN LE QUERNEC:
Cultural event posters
All 841 x 1189mm France

A range of posters by Alain le Quernec, displaying strong thematic approaches by the designer. The poster entitled **Bosnie** from 1995 (1) is offset litho-printed and shows a strong use of image – a silhouette of a head, angled upward with mouth slightly open, is traced out from a red brick wall, apparently dripping with blood.

This image is then made even more disturbing by the application of a large black cross. One band of the cross takes the form of a blindfold, and the combined image appears to signify the execution of a prisoner. Le Quernec set the type for the poster at an angle sympathetic to the angle of the head, further exaggerating the dynamic tension within the composition.

A similar cross metaphor is employed in the poster for the **Lahti Poster Biennale** 1993 (2). In this case, the figure struck out by the cross is a famous photograph of Lenin.

Liberty/Mandela 1997 (3) employs a simple yet extremely effective play on words. The statement 'La Liberté de Mandela' (The Freedom of Mandela) can also be read 'La Liberté demande la' (Freedom Needs This). The word play is extended into the caption – using the red, white and blue of the national flag, the statement 'Libertheid, Egalitheid, Fraternitheid' signifies the distinctions between the French national principles of Liberty, Equality and Fraternity and the apartheid regime in South Africa.

Le Quernec also designed a series of postcards commenting on the election of US President **George Bush** in 2001 (4). Each of the simple image/word games plays with one aspect of Bush's right wing agenda, from his support for relaxed gun laws to the rejection of worldwide environmental controls and the imposition of the death penalty. Le Quernec sums up his views on the president's political stance with a simple typographic word game, stating 'Bush/Bullshit'.

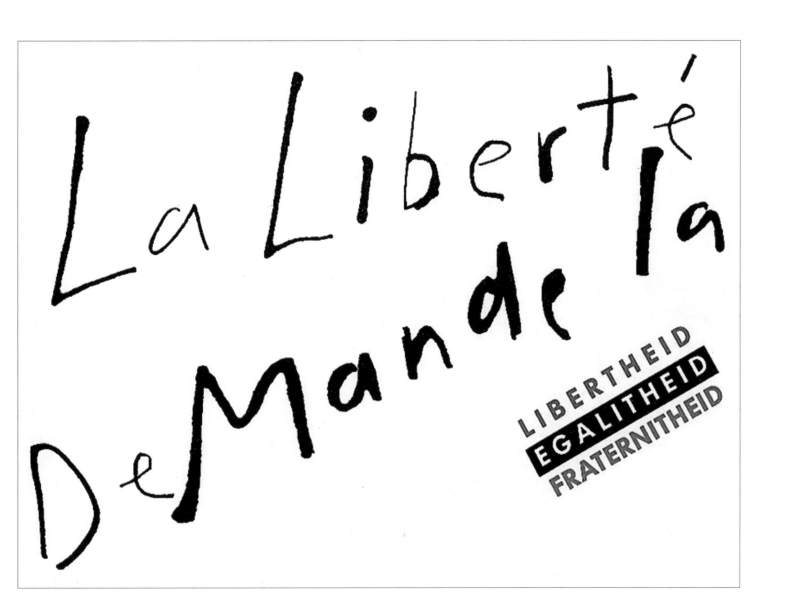

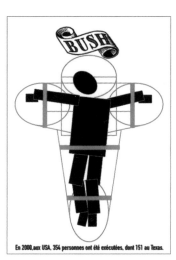

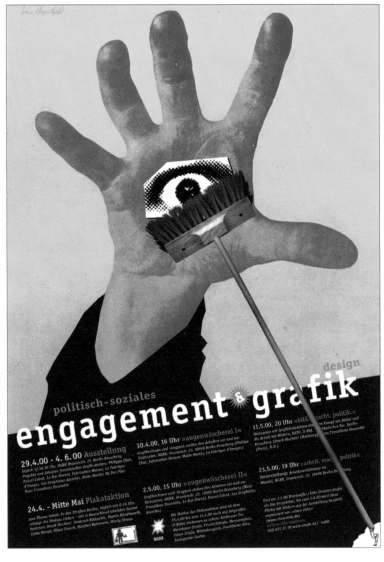

1 3 4
2

SANDY K.:
Engagement and Graphic Design
594 x 841mm Germany 2000

Engagement and Graphic Design (3) was designed for a campaign that set out to promote a project highlighting socially and politically engaged graphic design. The campaign involved an exhibition of work from French ateliers, mainly working in social and political contexts, together with a poster action and a book on the theme of 1 May, traditionally the international workers' day in Europe and the US.

The poster includes some interesting and playful references to other famous designers and designs. The image of a hand is taken from a famous political montage poster by John Heartfield, originally produced in 1928 as an election poster for the Communist party in Germany. The hand symbolised the number five, following the party election motto: "the hand has five fingers, with five you'll grab the enemy, vote list no.5/Communist!"

The combination of the brush and the eye make a direct reference to a quote by Roman Cieslewicz stating that designers have a responsibility to make images that "clean the eye". At the bottom right corner of the poster the designer has added a small cartoon character holding the brush. This simple element has a similarity to the French illustrative tradition of the work of designers within the collective Grapus, such as Pierre Bernard (pp92–93) and Alex Jordan (pp90–91).

The poster was litho-printed in full colour and was flyposted in the streets of Berlin, often deliberately adjacent to other political posters in an attempt to reflect on their effectiveness as vehicles for ideological dissent (1, 2).

1 2 3

SANDY K.:
Activist Video projects
Germany

Hybrid Video Tracks (1) promotes a video-based project in 2001 that included a wide range of exhibitions, talks and video screenings. The poster was designed to be flexible – the designer working with the printer to mask certain areas during the print run, thus creating four alternative posters from one original design, at a size 594 x 841mm.

Some posters include the television 'cut out' against a background image, while others feature the hands holding a blank sheet, which can be further manipulated or overprinted as required to promote specific events. Preliminary sketches and photographs (2) show how the designer works from initial concepts through to a working model of the final design. Invitation cards for the campaign featured the television screen die-cut so as to act as a simple viewing frame.

Ak Kraak auf Reisen (two posters shown together, 3) was designed as a single banner format, half an A2 sheet cut vertically to a size of 210 x 594mm. This unusual format was chosen as the poster needed to be small enough to fit in shop windows and on notice boards, while at the same time having a strong visual impact.

The posters promote a video magazine, and deliberately feature a white screen on the television set which can then be printed or overwritten with further details of local events etc. Designed to be produced on a limited budget, the posters were offset printed in two flat colours, red and green, in two opposing colour schemes on the same A2 sheet. The black television is made up from the overprint combined colours of the backgrounds.

ENGAGEMENT – DESIGN IS NOT ENOUGH*

Sandy K. (b. 1968) is a poster designer, based in Berlin, Germany. From his studio, Bildwechel (Image shift), he produces posters in collaboration with social/political groups or small associations, and has exhibited around the world. He was on the jury of the student competition for the Festival Internationale d'Affiches in Chaumont, France (2000), and wrote the introduction to the catalogue, raising the question, "What is a good political poster?"

Why posters, and what is so convincing about the poster as a form?
The poster basically comes from my clients. A lot of my clients are political groups or social groups, and there is also the poster culture on the streets of Berlin; fly postering, for instance, is still quite active. It was never a big question for me, why poster or why not? It's just the thing you do if you are involved with a political group or small association organising an event – it's part of the programme. It's not a graphic design choice, more a great gift to have such clients. Of course, this also reflects a belief in the social impact of images, and that those images belong in the public sphere, in the streets.

If those clients are concerned with getting a message across, why is the poster still a central device or visual voice employed, why not badges or banners or t-shirts or a publication?
I don't think there is much reflection on that by the clients or groups. If you are making an action, or demonstration, or event – a concert for instance – it's just the thing you do, it's part of the programme, as I said before. In Berlin you see new posters going up every day, it's very cheap to do, everybody can afford to do it, there are grants available so it's a very accessible and simple medium. It's also important that flypostering is part of a political action, a demanding of public space, it's taking or seizing the city or space and marking it as your space. A lot of the audience for the posters will come from the same area and will come to support the event anyway – so it's a bit like leaving a sign to communicate within a network of existing signs.

Your poster Engagement and Graphic Design has obvious references to John Heartfield's 1928 poster for the German Communist Party. The layout also makes reference to other

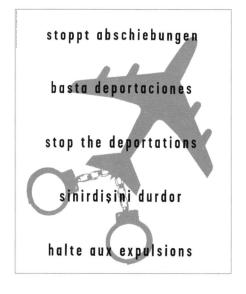

posters or poster designers' work. Did you mean to comment on how posters work generally, or does it operate as a homage to your influences?

Most of the posters I design function for a particular audience or a specific scene or context – I'm not making mass advertising or talking to the whole public in general. The Heartfield poster, or the homage as you called it, was intended for both a political and graphic design audience at the same time. The original poster is well known in Germany and by graphic designers in general. If you want to go a little deeper into the poster it has also a connection to Cieslewicz – he said that as designers we have a responsibility to find images that clean the eye and that I hope explains the central image. In the bottom right corner of my poster there is a small doodle or drawing, which refers a little bit to the work or style of Grapus. If you don't want to examine the detail you still have a strong poster, which, thank God, this nice guy made a long time ago.

Can you talk about what the original intention of the poster was?
The project Engagement and Graphic Design was one I was involved in with others in 2000. Its aim was firstly to sensitise the political scene to the importance of visual communication, by viewing it as the context of social and political battle. Examples were given from the ateliers within the Grapus tradition such as Graphiste Assoccies, Nous Travaillons Ensemble, Ne Pas Plier etc, and we made an exhibition with the work of those people. We also invited a few well known and not so well known designers

from Germany and asked them to make a poster on the theme of 1 May [the day commemorating international workers' rights and the traditions of the Labour movement] and work, and to put them up in the streets at the same time as the exhibition was going on. So the exhibition was in the gallery and on the street.

Secondly, the event was also talking to graphic designers about political action, showing how design could not only feature in the cultural pages of a newspaper but also the political pages. That's how I see myself in general; on one side working with small groups – ecological groups, political groups, small cultural associations etc – and on the other side I am a graphic designer.

Do you think these two sides are largely separate activities? Was Engagement in Graphic Design an attempt to bridge the gap?
It was an honest attempt made in the full knowledge that it would fail anyway. Identities are quite strong in both fields and it would be crazy to tell either that they have to work together. In the end there was quite an exchange and I think it had some kind of impact. There was a lot of good feedback from those working in the social field – teachers, social workers etc.

What is your reasoning behind the Hybrid Video Tracks poster? It seems to operate as a framing device, playing with the idea of looking through a window?
What I really like to try and do in my work is to reflect upon the media itself. I have done a number of projects for video activist

1 2 3 4 5

Sandy K.
(1) World poster (1999)
(2) Your TV (1995)
(3) Stop the Deportations (2000)
(4) Free movement is our right! (2001)
(5) Explosion (1998)

groups such as the Hybrid video project you mention. It's kind of a trick or a critique; to reflect on the media – who are defining the frame through which we see things, choosing what we see and deciding what is left out – the basic problem of the mass media in general.

Television and video media in particular?
Also newspapers and photography – every photographer who looks through a viewfinder makes a decision on our behalf. I could of course have put the TV into the hands of the viewer on the poster but I wanted to use a two-dimensional frame such as a photographer or film-maker might use.

The television seems to be quite a recurring or strong metaphor in your work; is that also a reference to the media in general again?
Yes, it is related to that; for instance, the blank screen could be seen as referring to the audience. I don't know how many posters I have made with TVs and blank screens, maybe three or four. What's interesting is that whenever those posters are displayed in the streets, people write into the blank spaces of the TV screen – it's like they are speaking via a more powerful medium.

Where your work is displayed publicly are you able to get feedback or can you gauge responses to the ideas and messages in the work?
I don't have any problem when people intervene in the work itself, even if it is in a negative way – if you are getting a reaction to a poster then it's really great. Even if they destroy them with a

marker pen or pull them down or something if they don't like the content or the image. It's sad but it's good. That is better than getting your work selected for a stupid poster competition or featured in a magazine.

Why does a lot of your work appear stripped down, without much decoration, even quite brutal in some cases?
Most of my posters are very low on design in terms of there not being a lot of ornamentation on them: they are more to do with the images I use. This has a lot to do with the surroundings where the posters will be displayed – there is a lot of visual noise on the streets. The poster has to be, as the Kassel School would say, 'a surface which jumps into the eye'. And if you design for the street the design process does not end at the edge of the poster. Part of my work is trying to sensitise those people who are putting up the posters. The people who are putting up the posters are doing half the design – they are designing the public space.

Could you comment on the use of human elements in your work such as hands and eyes for instance – is that a conscious act?
I have always been influenced by Grapus and the tradition of using handwriting and elements of the human form; limbs, gestures etc to create a more personal and humane feeling in the work. This is in contrast to a lot of design that is around at the moment, which is more influenced by industrial production which brings along with it a particular aesthetic – the computer, hard angles and lines, metallic inks... I see myself in opposition to

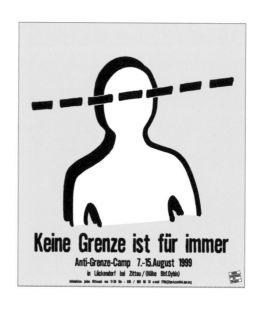

that direction in design. Design for me is social communication for groups or individuals. Design is more about social progress than technical progress. When I am designing a poster I think in images: very clear, reduced images. I think this is connected to the Polish tradition of poster design, the work of people like Tomaszewski who in turn influenced French design groups such as Grapus, and people like Alex Jordan who taught me at the Kunsthochschule Berlin Weißensee. The most important thing to consider is the audience and to make every effort to be responsible, to change and develop culture and democracy and communication. It's not about propaganda or the ego of the designer. If you accept that you have a responsibility, then you have within that the word 'response' – an understanding of communication – and 'ability', which refers to our profession.

There are designers who are known foremost as poster designers and then there are graphic designers who also make posters, alongside other graphic outputs. How would you classify yourself? That's a trickier question than it seems. What I said about responsibility goes for every profession – if I were a baker for instance I would also be a concerned citizen, a political person, a social person. In this case I make graphic design. I used to make video, for me the media is not that important. To be in a position to design posters is a great gift. I don't know any graphic designers who would say no to designing a poster. I've never thought about posters like this before, but the poster refers to the artist. For most of Europe, even though graphic design comes

from the Industrial Revolution, the poster is the artwork. It's kind of like the picture, the drawing or painting in that the media refers to art. But we are not artists – we believe in mass production and distribution as a form of democracy. And we do not necessarily believe in a reception channel which is created by the artist's name or by the gallery or the museum. We believe in public space: our piece of art is not necessarily connected to the person or the individual who created it.

* Design is Not Enough was the working title for an atelier run by Sandy K. and other activists at the Declarations of Interdependence Symposium, Montreal, Canada in October 2001.

1 2 3 4

Sandy K.
(1) Wing TV (1997)
(2) No borders (1997)
(3) Südosten (2000)
(4) Party EX (1997)